Colstrip, Montana

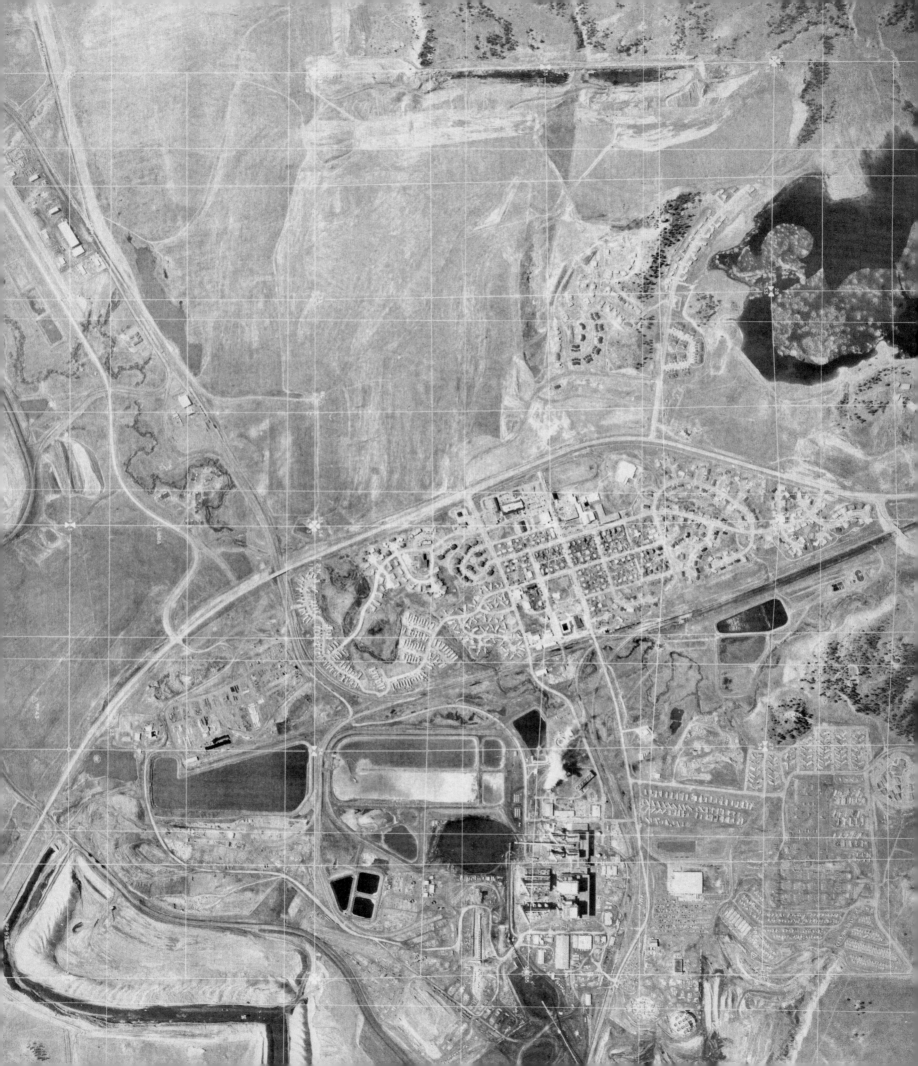

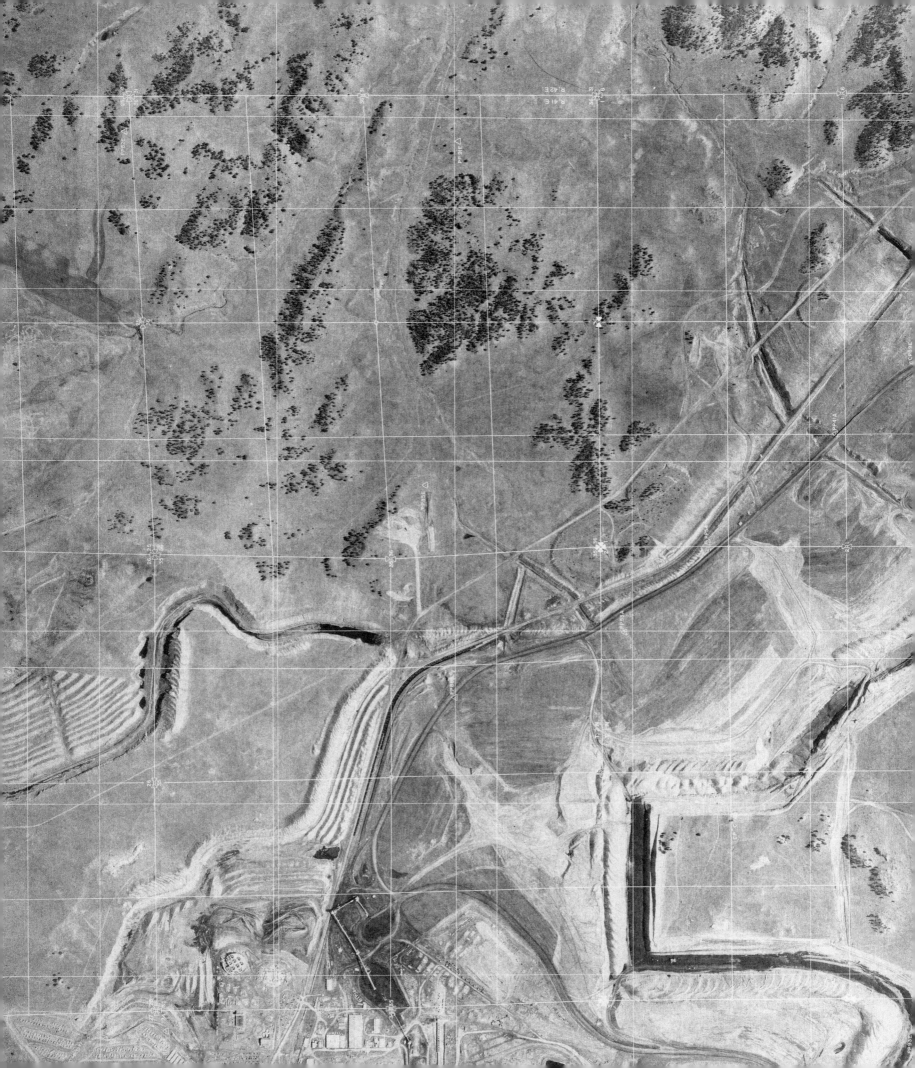

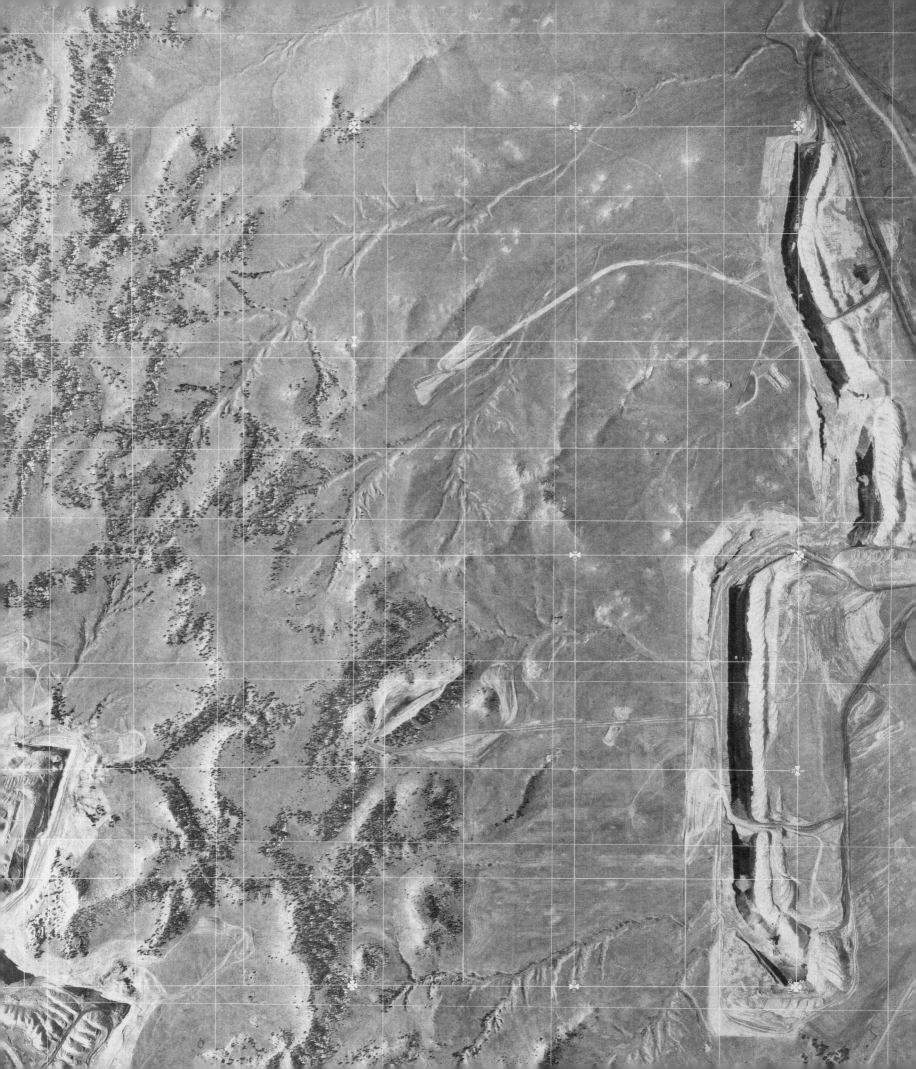

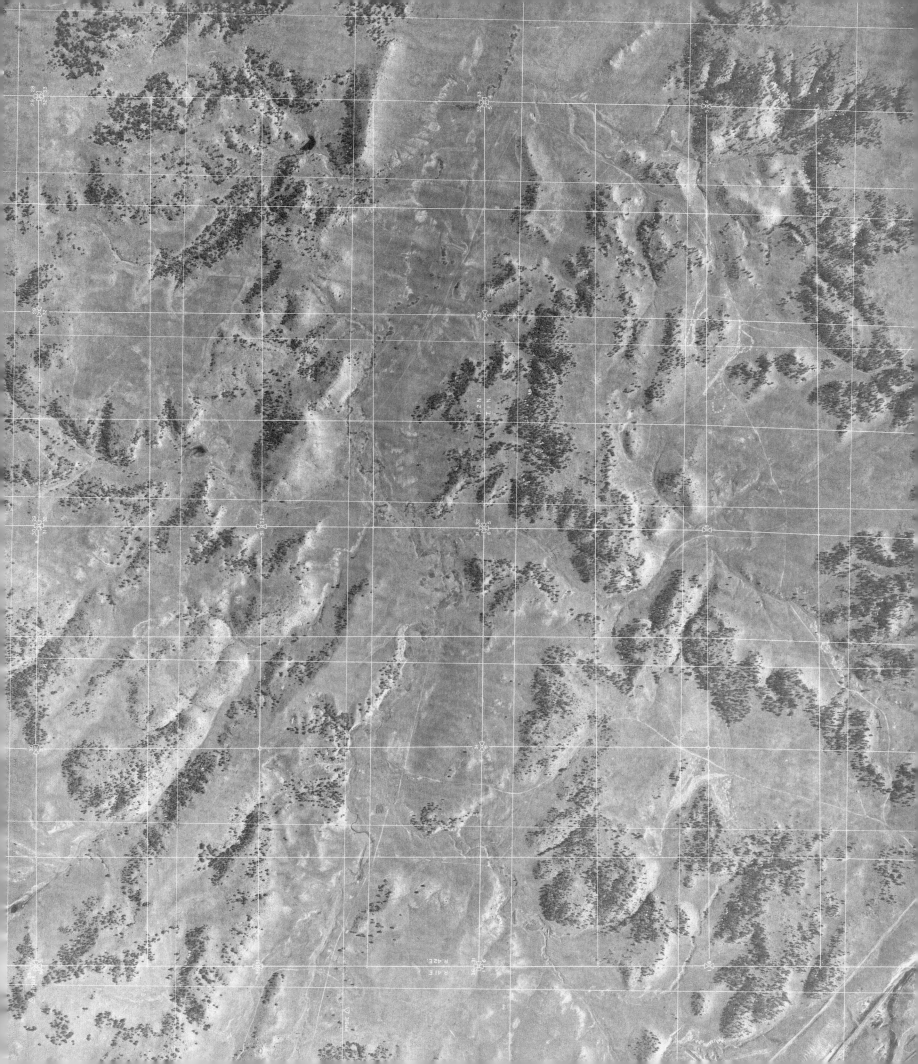

Colstrip, Montana

David T. Hanson

Essay by Rick Bass

TAVERNER PRESS

Notes on Colstrip

David T. Hanson

Colstrip is located in southeastern Montana, in an area where the High Plains rise to meet the Rocky Mountains. The site is flanked to the east by open rangeland and farms and ranches in a terrain covered with yucca, sage, native grasses, and occasional pine and cedar trees. On the other side of Colstrip are the forested foothills of the Bighorn Mountains. The area is rich in minerals and other natural resources and has become a prime example of "energy colonization." It serves the dominant interests of the East and West Coasts, which exploit the deposits of coal, oil, natural gas, oil shale, uranium, copper, and other rare metals buried there.

The coal being mined near Colstrip is part of the Fort Union Formation, which underlies much of eastern Montana, Wyoming, the Dakotas, and Saskatchewan. It dates from the early Paleocene era, some sixty-five million years ago. At that time, the continent was covered by an inland sea stretching from the present-day Rockies to the Appalachians. Eastern Montana was at the shifting edge of this sea, which was bordered by swamps and active volcanoes to the west. This was just after the Cretaceous Extinction, the still unexplained period of ecological disruption that destroyed most of the plant and animal life in the northern hemisphere. Over half of the plant species in eastern Montana disappeared, along with the dinosaurs and most of the other land animals; some of the water animals (early crocodiles and aquatic turtles, for instance) fared better. Following the Cretaceous Extinction there was a rapid change from a "sub-humid" climate to a warmer and wetter one. Water tables rose, diverse plant life returned, and broad-leaved, evergreen-type vegetation eventually prevailed, which allowed for the formation of peat, the precursor of coal. The landscape probably looked much like the Florida Everglades does today, with low swamplands cut by rivers and flood plains.

Over a period of five to ten million years, up to five hundred feet of decaying vegetation was accumulated in the swamps. The piling of new on old was made possible by weaknesses in the earth's crust that caused the bottoms of older basins (such as the Powder River Basin, which includes the Colstrip area) to slowly sink. As the young mountains to the west began to lift, sediment eroded off their slopes, filling in the basins to the east and burying the plant material, cutting off the hydrogen and oxygen and preserving the carbon. Gradually, over eons of active mountain building, the com-

pacted vegetation was buried to depths and under pressures and increased temperatures that accelerated its transformation and caused it to become soft, flaky, low-sulfur subbituminous coal. This stratum reached its maximum depth about thirty million years ago. With the uplift of the Rockies, wind and water slowly eroded away over five thousand feet of the overlying rock, leaving only eighty to a hundred feet of soil and rock covering a seam of coal twenty-four feet thick.

For the past ten to twelve thousand years, the landscape of eastern Montana has appeared much as it does today. Vegetation slowly shifted from forest to grasslands. The animal life changed more rapidly. Today it is hard to imagine the camels, elephants, and other large mammals (including mammoths) that grazed there. The present-day fauna consists of antelope, deer, upland game birds, hawks, eagles, coyotes, and a variety of small rodents.

In relatively recent times, since about 1700, the place that is now Colstrip was part of the tribal land of the Crow, who called it both "Where the Enemy Camps" and "Where the Colts Died." The town came into being in the 1920s, when the Northern Pacific Railway began mining coal there for its steam-powered locomotives. In 1959, after diesel power had replaced steam, Northern Pacific sold its coal leases, its mining machinery, and the townsite to the Montana Power Company. As more stringent federal air-quality controls were enacted and municipal utilities began looking for low-sulfur coal, Montana Power expanded the mine for its own coal needs as well as for sales to industries and utility companies in the Midwest. During the national energy crises of the early 1970s, two coal-fired units generating electrical power were built at the mouth of the adjacent Rosebud Mine. In the early 1980s, two larger units were built. Although the power plant was far from where the energy was actually needed, it was also far from urban areas already suffering serious pollution problems.

The Colstrip power plant is the second largest coal-fired power plant west of the Mississippi. It is the tallest man-made structure in Montana, with stacks that rise over seven hundred feet into the sky. It is now owned by a consortium of power companies and produces more than 2.2 million kilowatts of electricity a year. Over two-thirds of the electricity is exported to the Pacific Northwest via

an extensive system of power transmission corridors cutting a swath three hundred feet wide across nearly fifteen hundred miles. The mines and industrial site extend over fifty square miles. Since the mines first opened in 1924, over 550 million tons of coal have been dug up. Enough earth has been moved to fill both the Erie and Panama canals five times over. Yet there are still more than 120 billion tons of coal reserves in Montana: 25 percent of the total coal reserves in the United States.

The Rosebud Mine has been owned by the Westmoreland Coal Company since 2001. The strip-mining method employed is relatively straightforward. After a ten-to-twenty-year plan has been approved by state and federal agencies, a vast grid of one-to-two-mile-long adjacent bands is mapped out. Layers of topsoil and subsoil are removed and stockpiled for later use in reclaiming the land. Another hundred feet of sandstone, shale, and clay "overburden" is drilled into, packed with ammonium-nitrate and fuel-oil explosives, and blasted. A fleet of mammoth power shovels does the work of clearing away the earth and rock to expose the seam of coal below. The largest of the earth-moving machines at Colstrip is the Marion 8200, an eight-million-pound walking dragline that was being built in Colstrip when I began to make photographs there. It was assembled on-site over eighteen months at a cost of nearly $20 million. The size of a large office building, complete with control rooms and power decks, the Marion 8200 is emblazoned with the image of a buffalo, the logo of the mining company. It has a boom that reaches more than three hundred feet out over the earth and it carries a shovel that can move a hundred tons of rock in a single bite. The dragline works its way up and down the strips, systematically removing earth and rock from one strip and dropping it into an adjacent strip from which the coal has already been excavated.

The coal is loaded into haulers and trucked to tipples, where it is crushed and then transported via conveyers to storage areas or to railroad cars. Twenty-five percent of the coal mined at Colstrip is shipped to Midwestern power companies. The rest is fed into the Colstrip plant to fuel giant steam-powered turbines. These boilers consume 1,200 tons of coal each hour, or roughly one acre of land every day and a half. The plant is dependent on water to both fuel and cool the steam generators and to flush out its waste products. Since Colstrip is located in a dry area, two pipelines have been built to

tap into the Yellowstone River, thirty miles north. The plant consumes nearly 22,000 gallons of water every minute. A fifty-day backup supply is stored in a reservoir that also serves as the town's recreational facility.

Surrounding the plant and town is an extensive system of ponds containing a variety of industrial waste products generated by the plant. The majority of these are settling ponds in which suspended waste material slowly sinks to the bottom, where it can be dredged up and trucked to nearby dump sites. There are also a number of warm-weather evaporation ponds in which the wastewater is channeled through a system of sprinklers that spray it into the air so that it can evaporate, leaving desiccated waste on the ground. Inevitably, the waste from the various ponds works its way into the underground water table and local and regional streams and rivers used for irrigation and for livestock. (Official "acceptable leakage" from the waste ponds amounts to a discharge of thousands of gallons of wastewater per day.) Billowing plumes of smoke emitted from the stacks carry yellowish clouds of sulfur dioxide across much of southeastern Montana and parts of Wyoming and South Dakota, causing sulfuric acid to fall onto the landscape in cold weather. The plant emits more than four hundred pounds of sulfur dioxide each hour, in addition to nitrous oxides and a variety of other toxic substances. According to a 2009 report by Environment America entitled "America's Biggest Polluters," the Colstrip plant is one of the dirtiest plants in the nation.

The final stage of the mining process is the reclamation of the land. Federal and state laws require that the mine pits be refilled, graded to the approximate contours of the original terrain, covered with subsoil and topsoil, and then seeded with a mix of trees, shrubs, and native grasses resembling the regional vegetation. Reclamation is relatively expensive. Costs run between $16,000 and $25,000 per acre. (On the other hand, the coal mined from that acre of land is worth approximately $350,000.) Although some mined land at Colstrip has been reclaimed, primarily in high-visibility areas along highways or in one or two public demonstration sites, most of the disturbed land has been left unreclaimed. Areas mined prior to 1977, when reclamation laws went into effect, need not be reclaimed and in most cases have been left as they were when the mining was finished.

Various legal alternatives to reclamation have been employed, including converting the mined land to industrial sites or developing it as residential and commercial real estate. But the most difficult aspect of mine reclamation, reconstituting the groundwater system, remains a problem without a solution. The mining process inevitably disturbs or cuts off natural drainage patterns. The aquifers are disrupted indefinitely when they are intersected by the mining, draining precious water into the mine pits, contaminating it with acid runoff from the mines and spoil piles, and polluting it with silt and toxic metals. As the water tables in the area are lowered, both the quantity and quality of water downgrade are affected. In this semi-arid terrain, the barely adequate water supply is critical for agriculture and grazing. Even farmers and ranchers far from the mine have had problems with their wells being contaminated or drying up. Most of the town's wells were severely contaminated and have been closed.

When I was working in Colstrip, from 1982-85, the third and fourth units of the power plant were being built and the town was experiencing a construction boom. The population, two-thirds of whom lived in mobile homes and trailers, had tripled in two years to nearly 8,000. This was the New West, a modern version of a rough frontier town, typical of the communities that spring up during the periodic booms that sweep through this region of the country (the gold boom, the oil boom, the uranium boom). Along with the rapid influx of people, Colstrip had experienced dramatic increases in alcoholism, drug abuse, crime, and a wide range of related social problems. After construction was completed, in 1985, the town began to more reasonably approximate the "carefully planned, award-winning community of 5,000 residents" that the company promotional literature had advertised. Twenty-five years later, there have been layoffs at the mine and the plant, and the population has dropped to around 2,500.

Colstrip remains, strangely and disconcertingly, much like a classical nineteenth-century factory town. The power plant and stacks, with their clouds of steam and yellow-stained smoke, still tower over the town below. Nearly all the residences are in direct line of sight of the plant, with its

flashing lights, constant drone of turbines and cooling towers, and intermittent, clearly audible sounds of loudspeakers broadcasting announcements and paging workers throughout the day and night. Dust from miles of exposed soil and coal piles works its way into everything—trailers, houses, stores, and cars. Swiveling draglines are visible, sirens warn of explosive detonations, and the reverberations of mine blasts shake the ground. Steel transmission towers and high-tension power lines dominate the sky, often directly above or in close proximity to houses and mobile homes. Surrounded on all sides by the power plant, industrial site, strip mines, and waste ponds, the town of Colstrip is dwarfed by the industrial activity that spawned it.

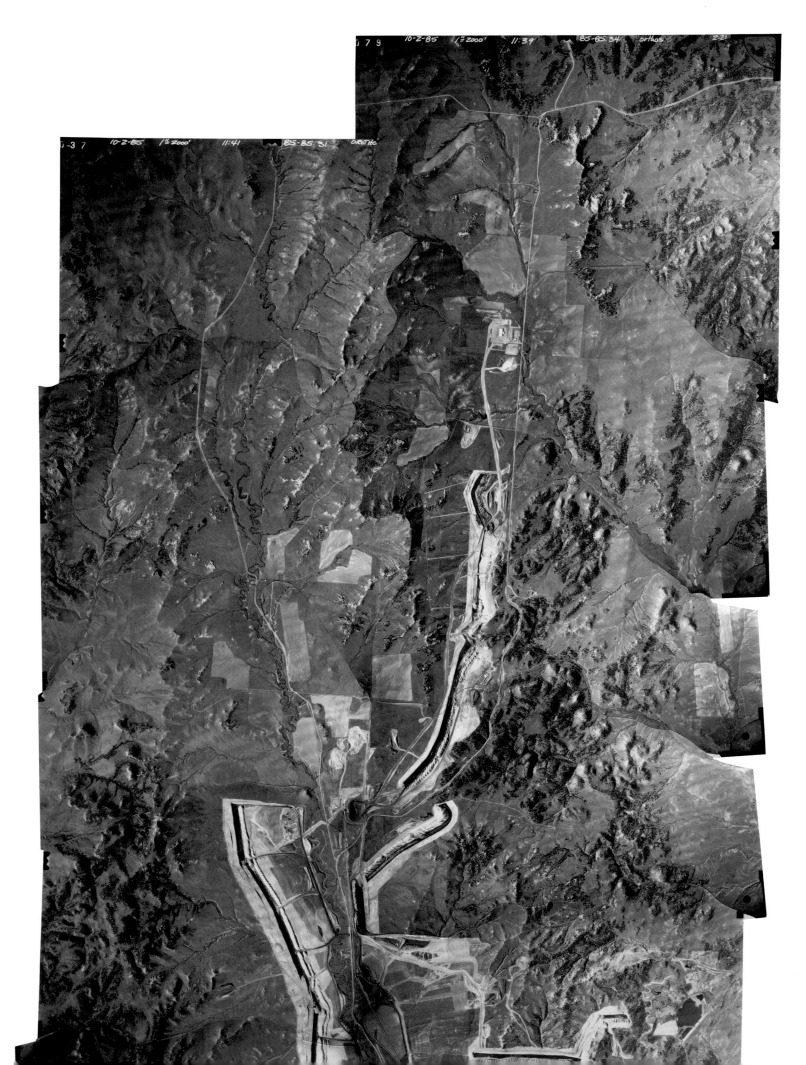

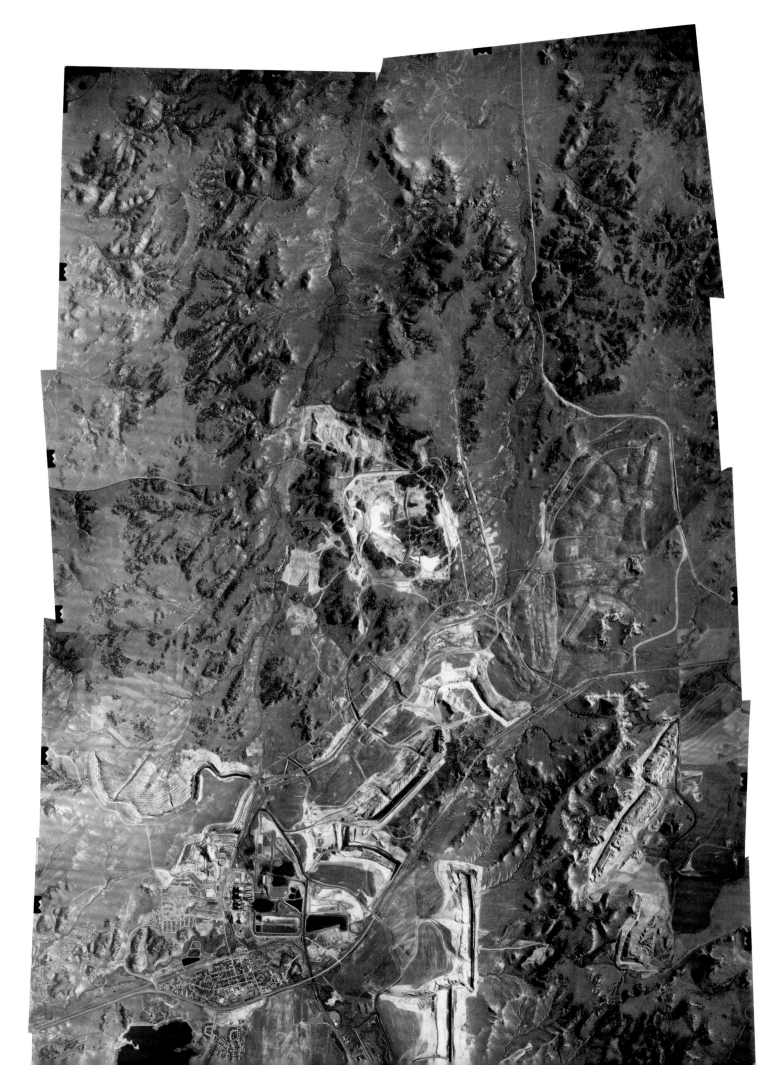

Colstrip, Montana

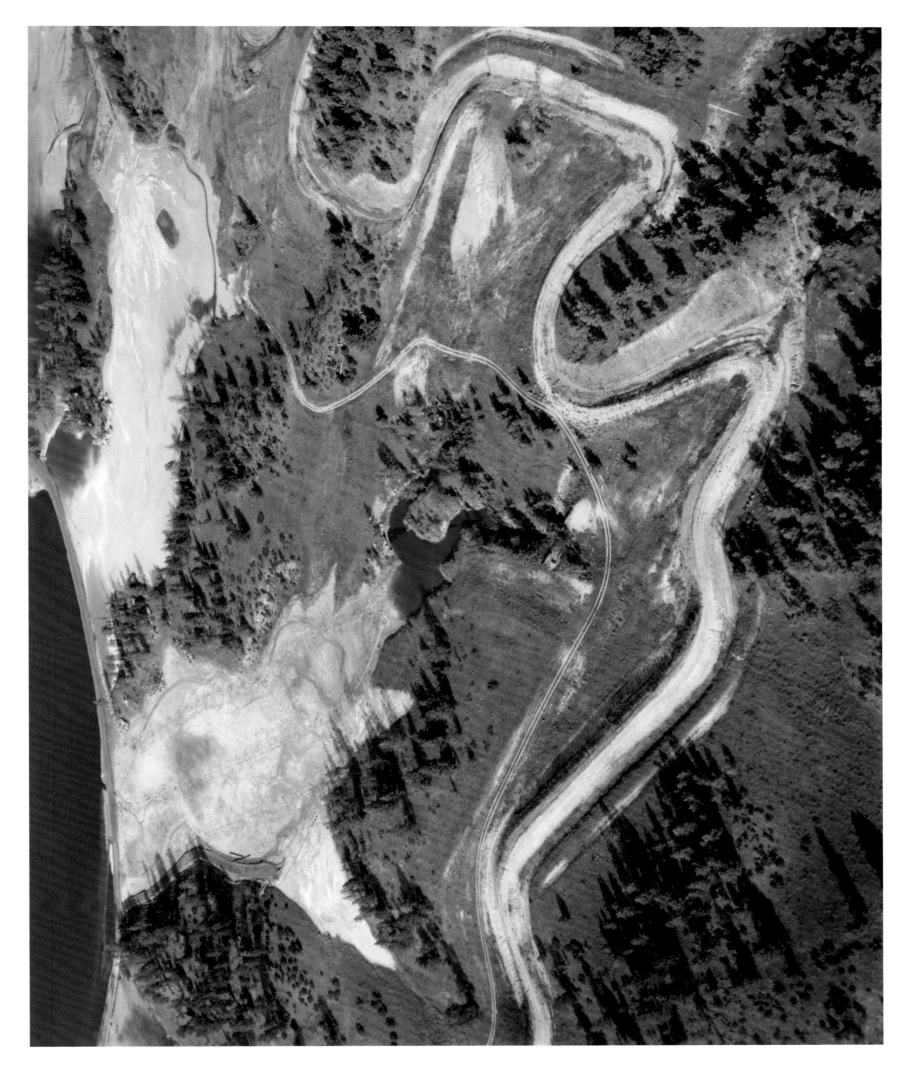

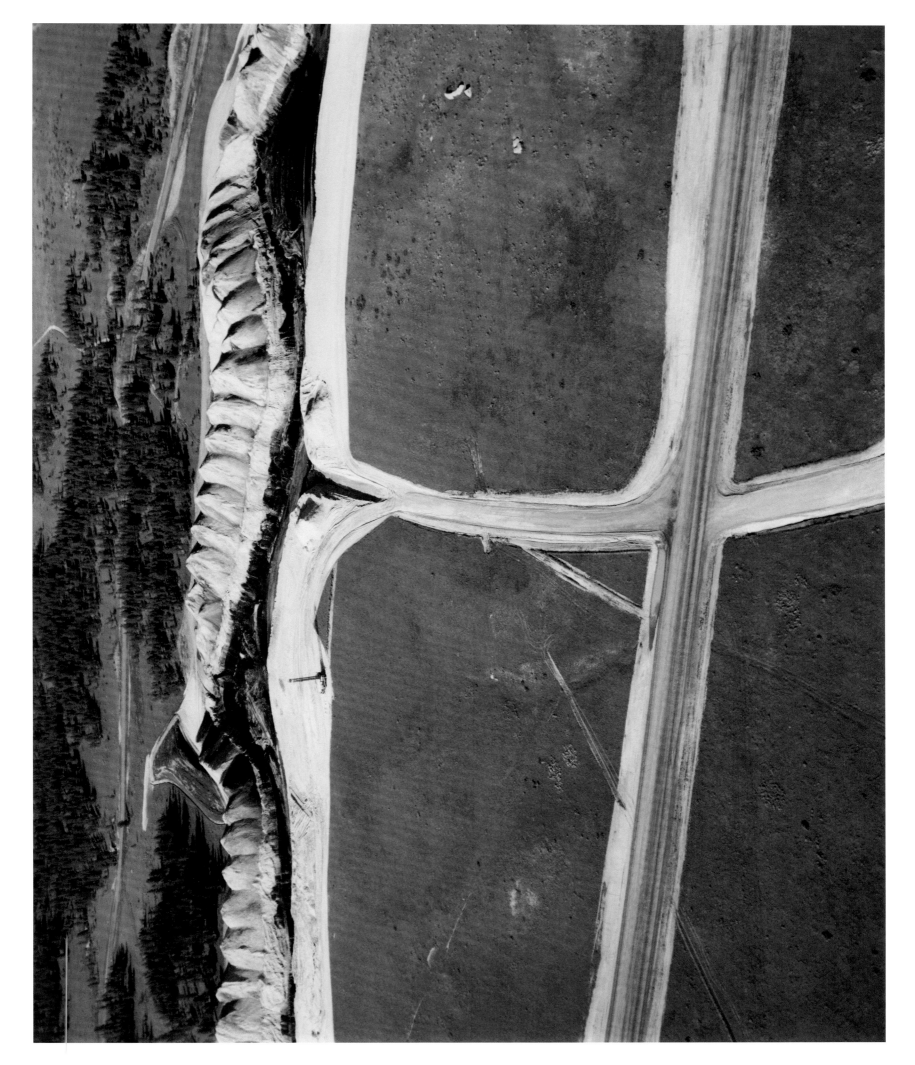

New mine area, clinker, and mine roads along Armell's Creek

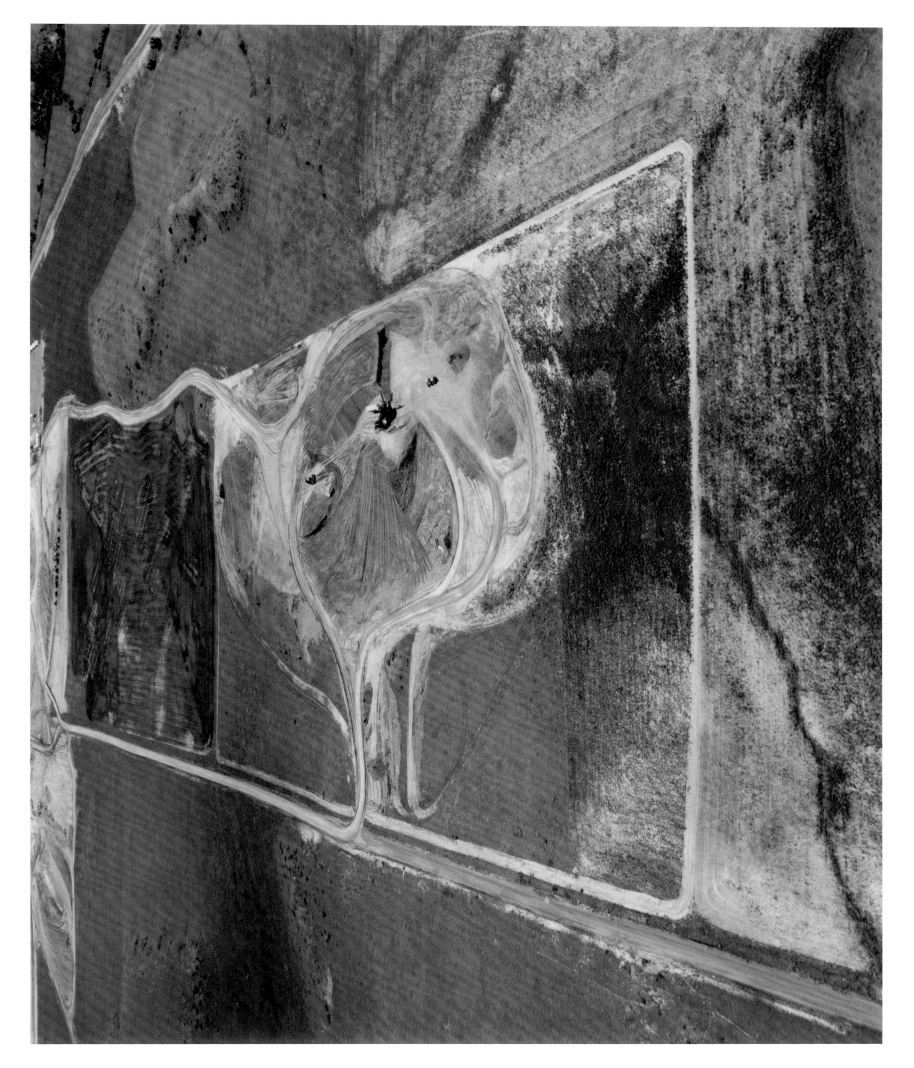

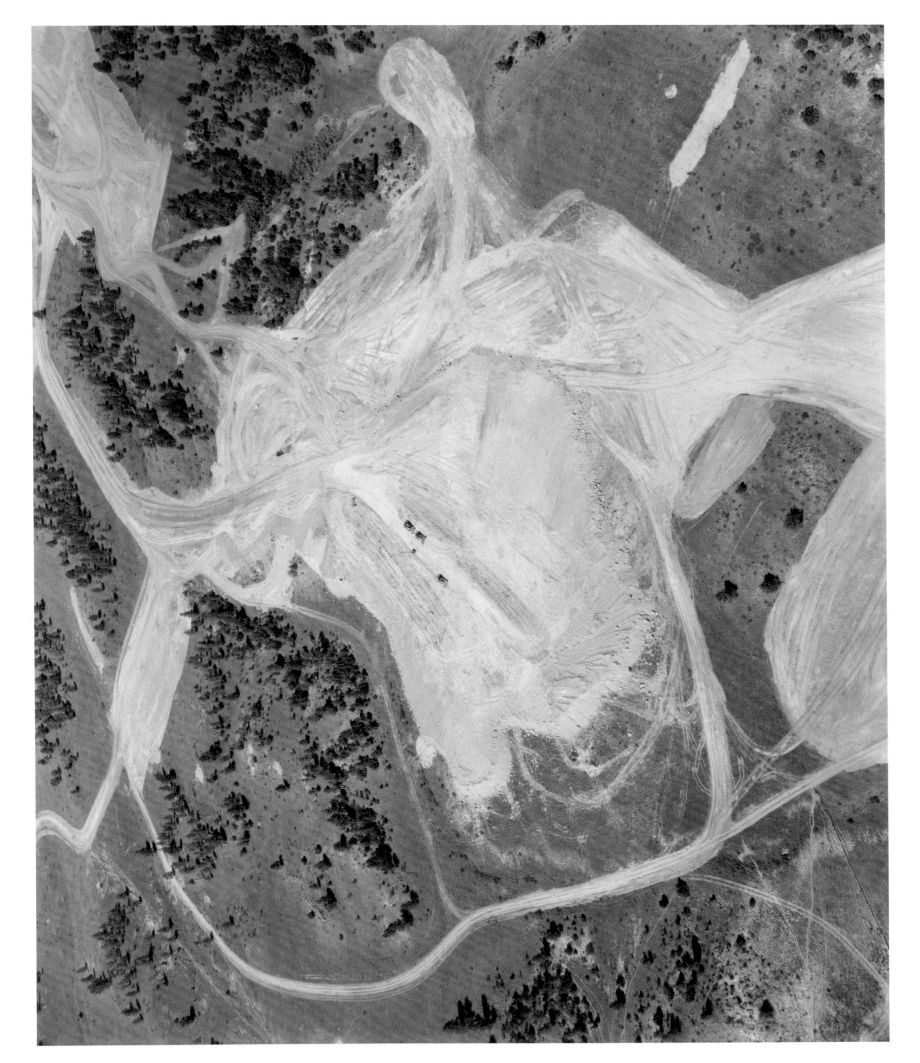

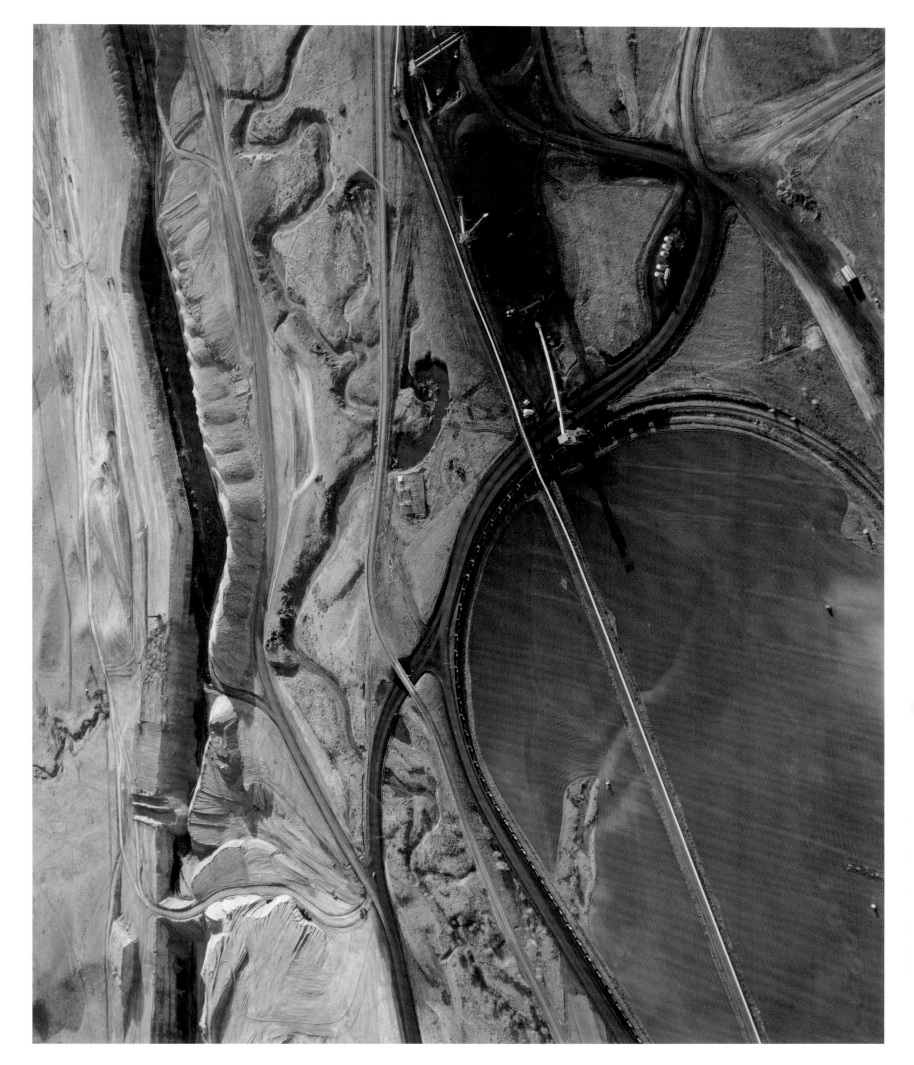

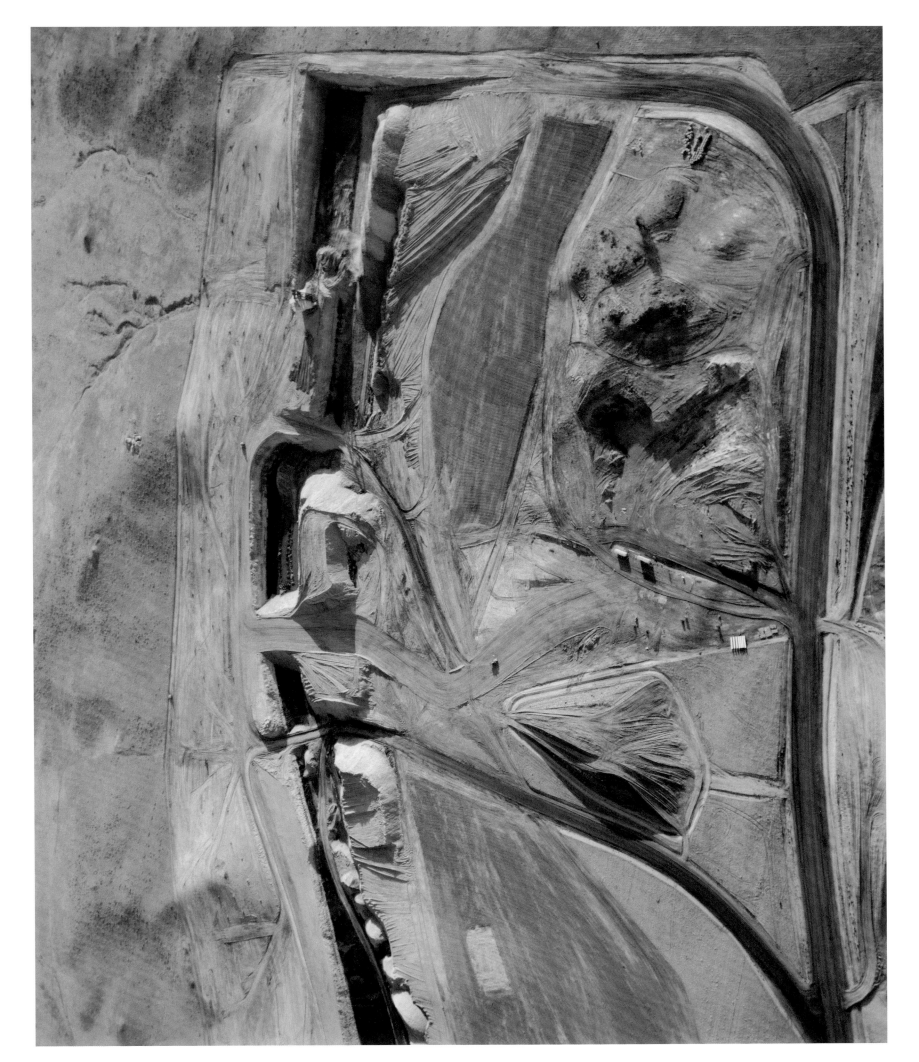

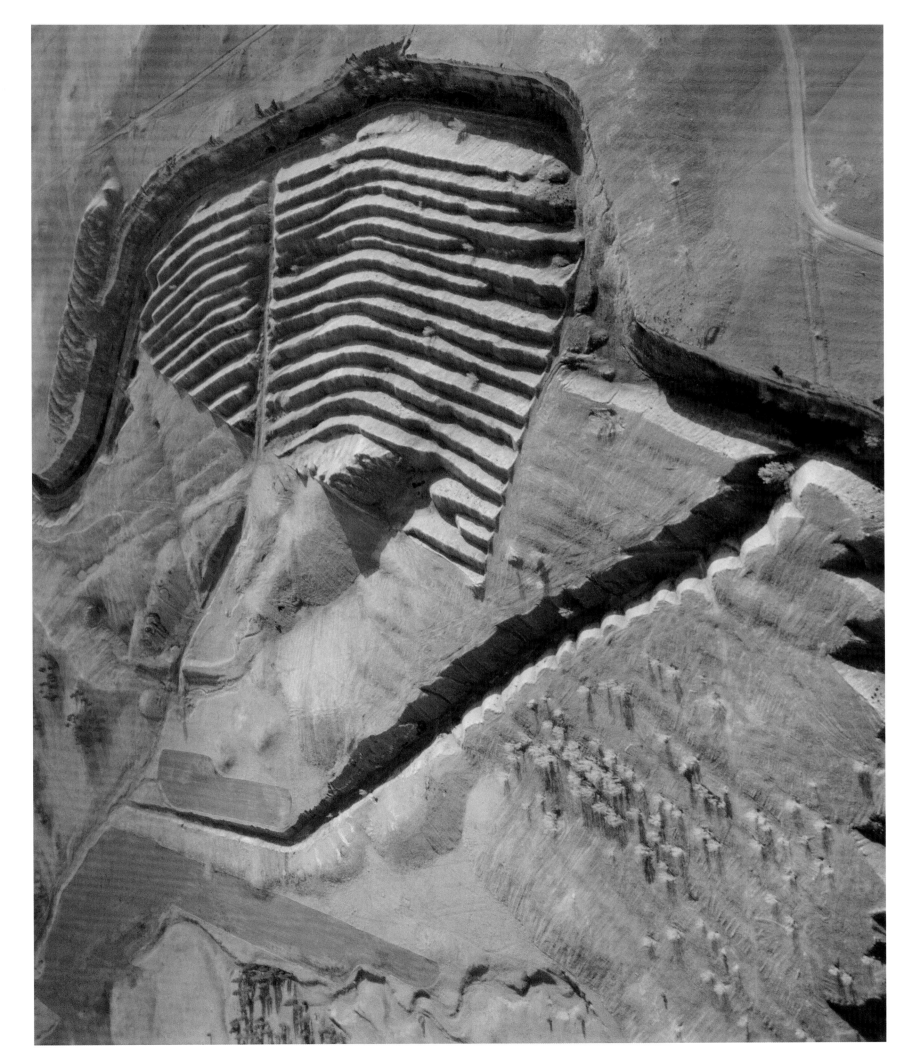

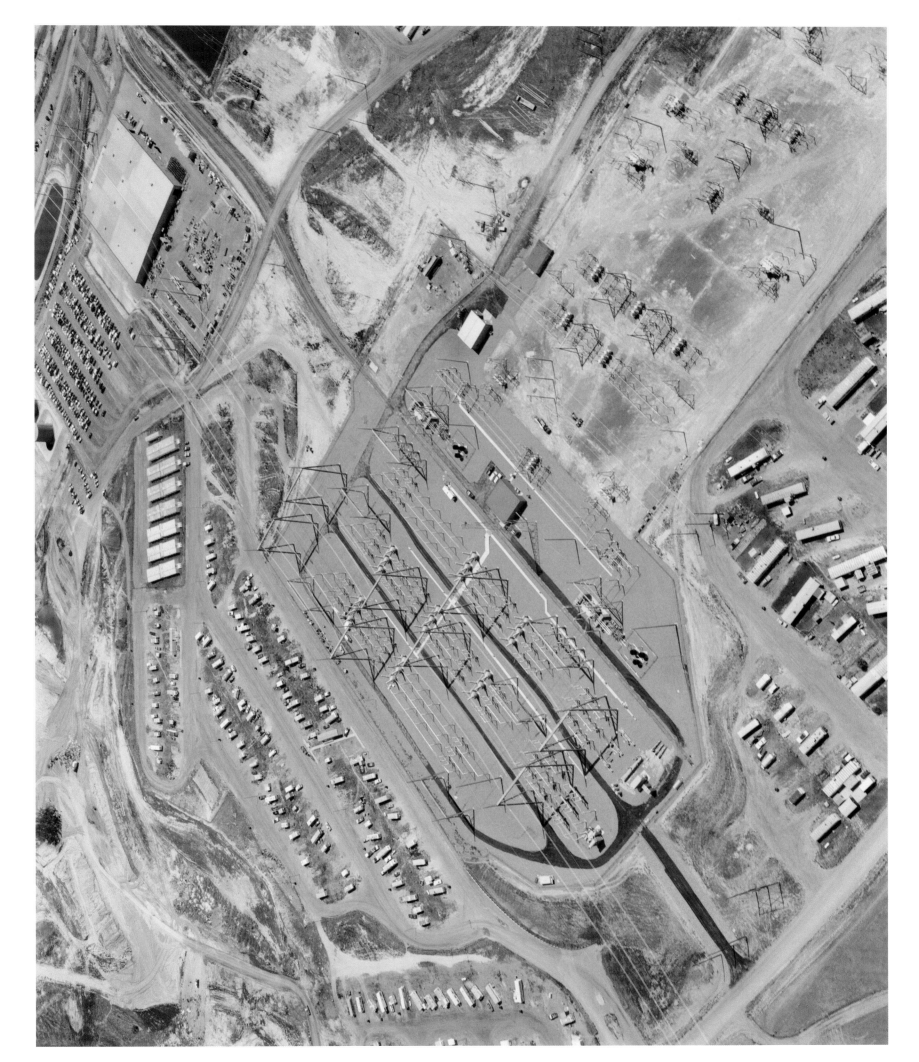

Power plant, waste ponds, and residential areas

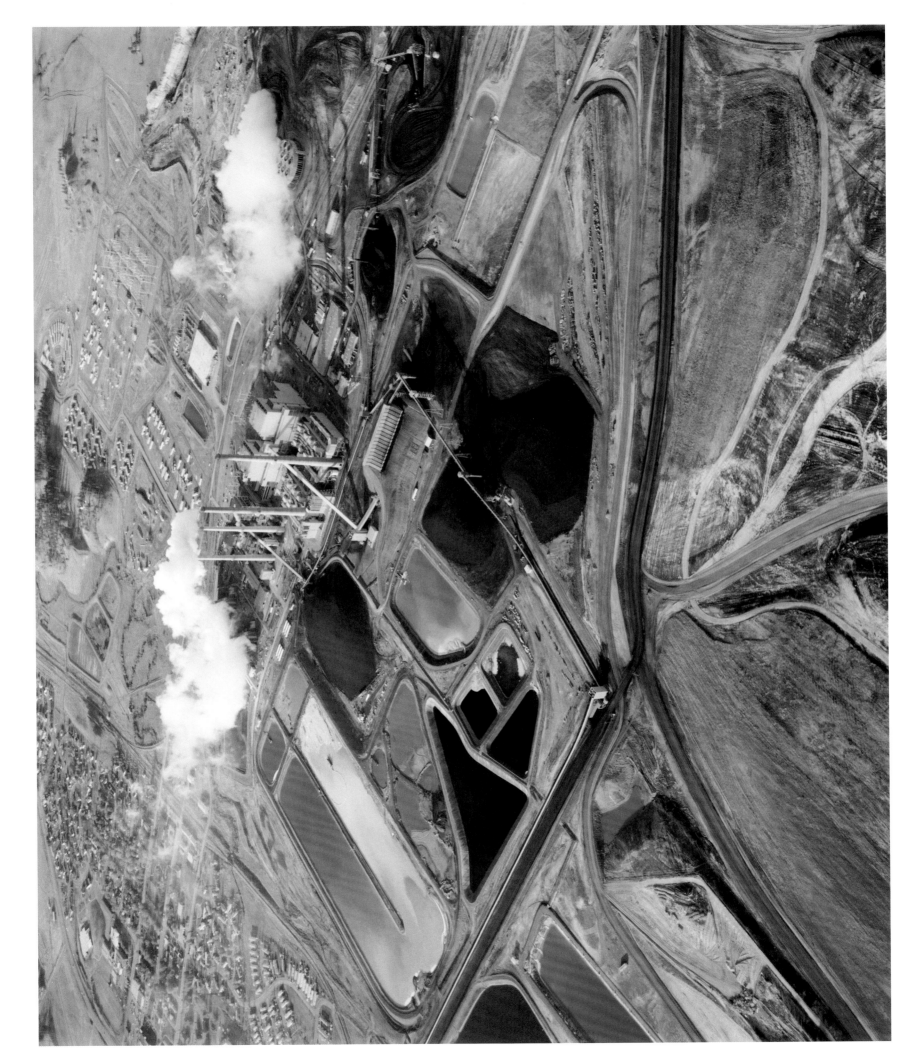

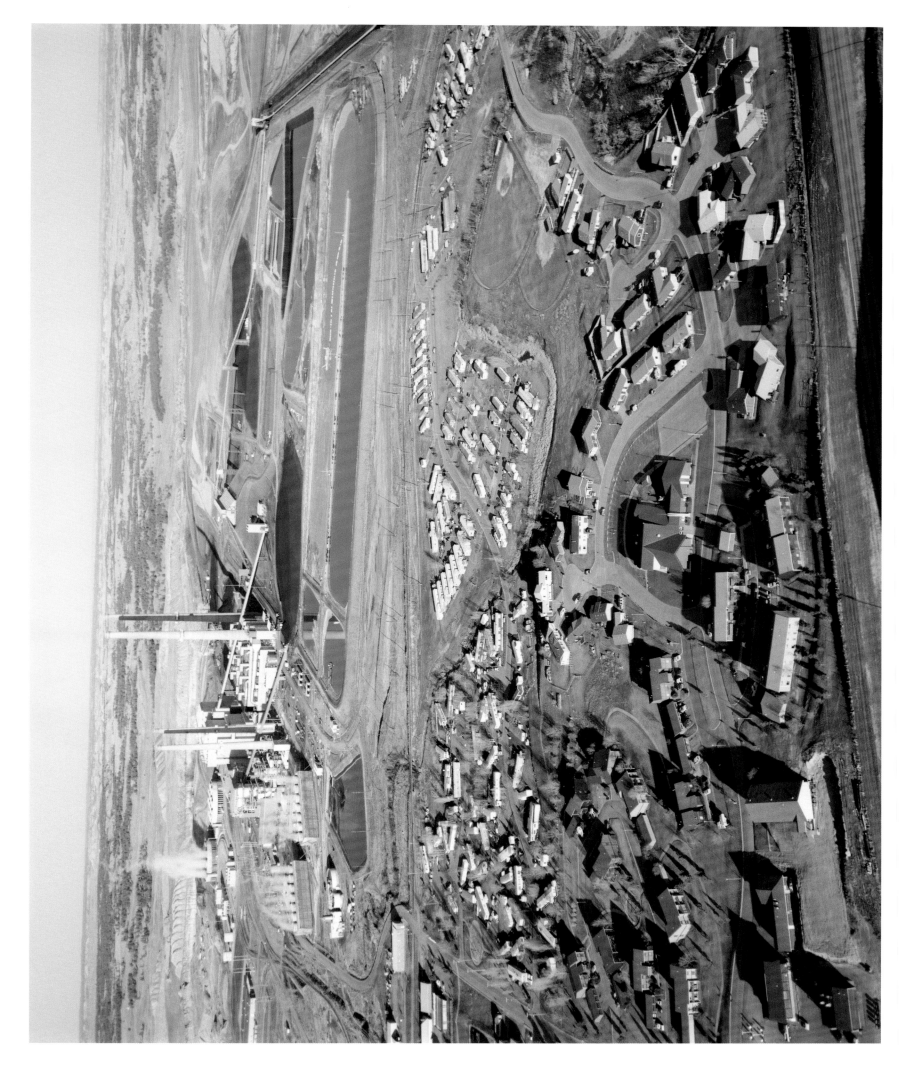

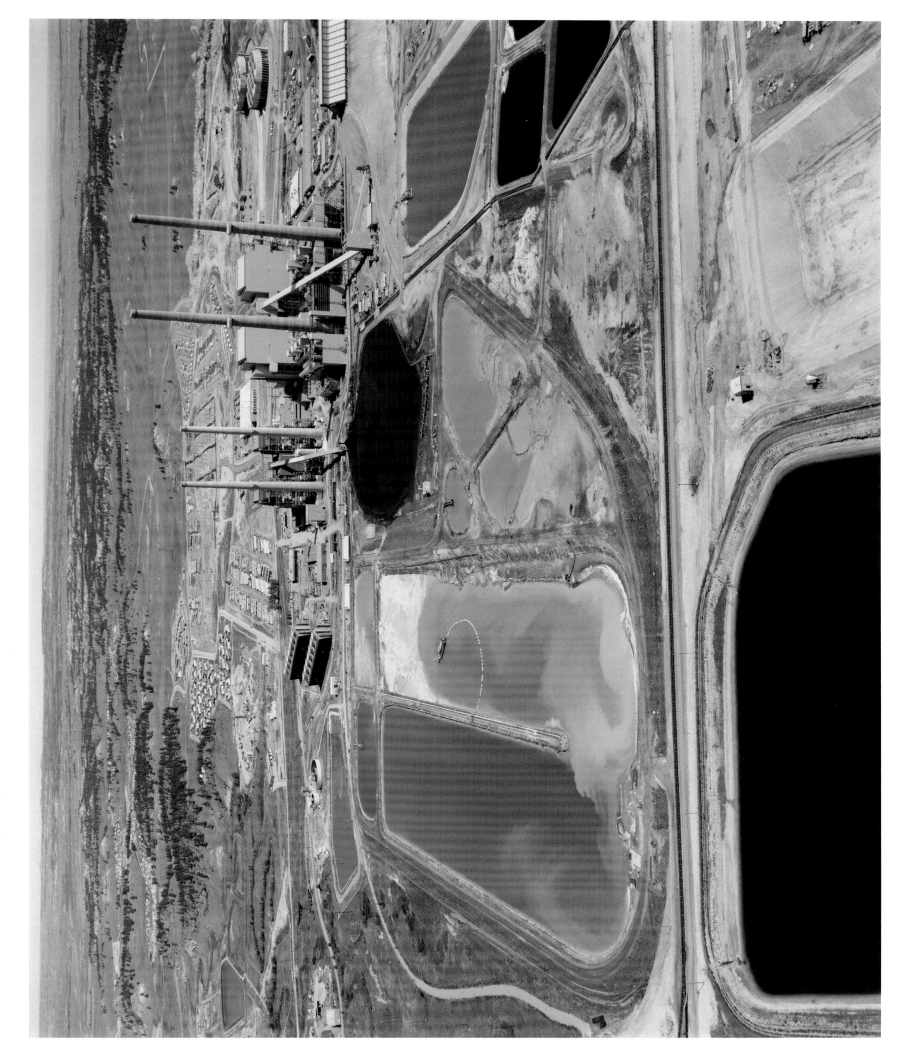

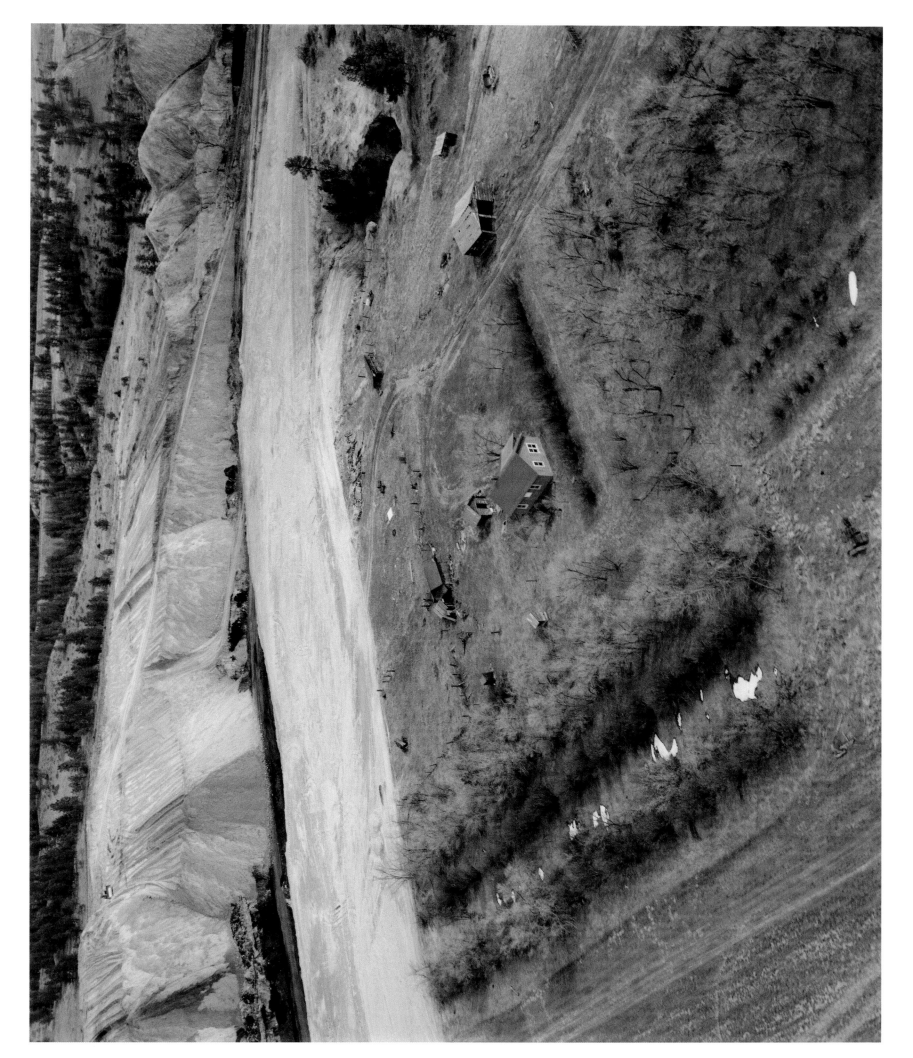

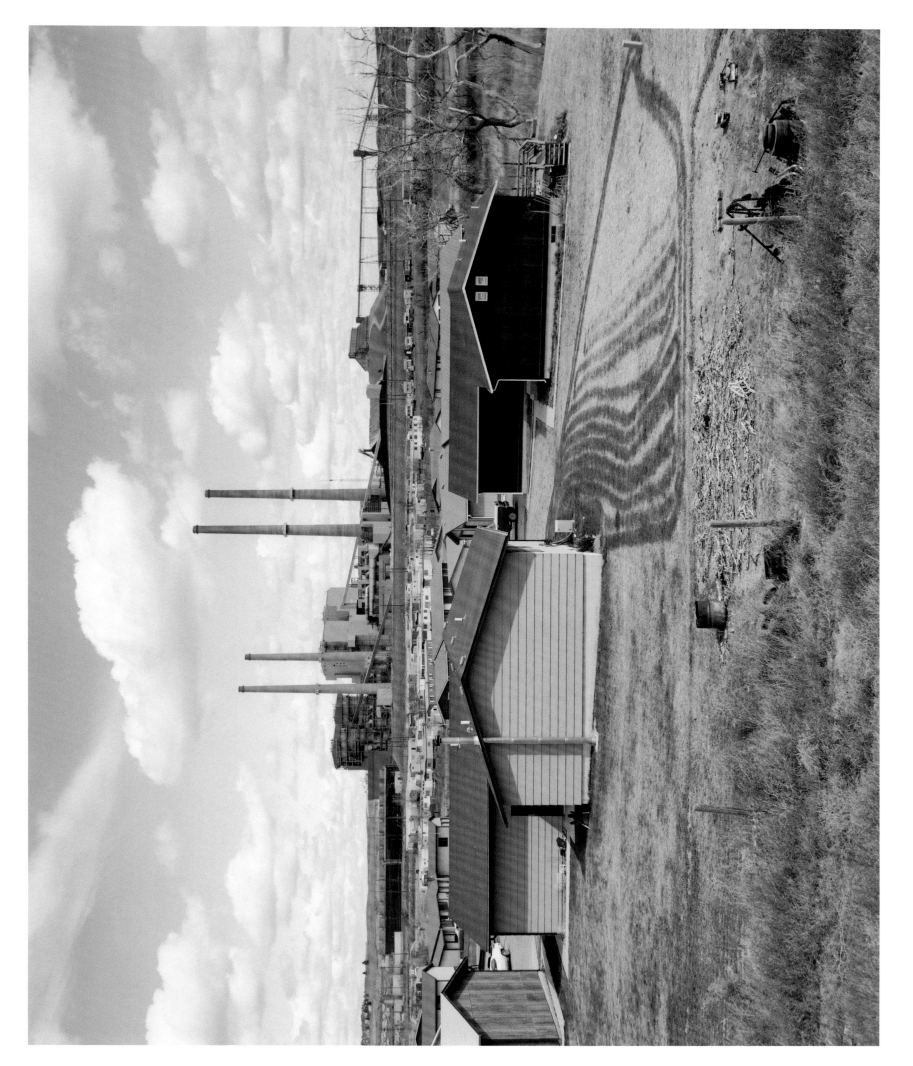

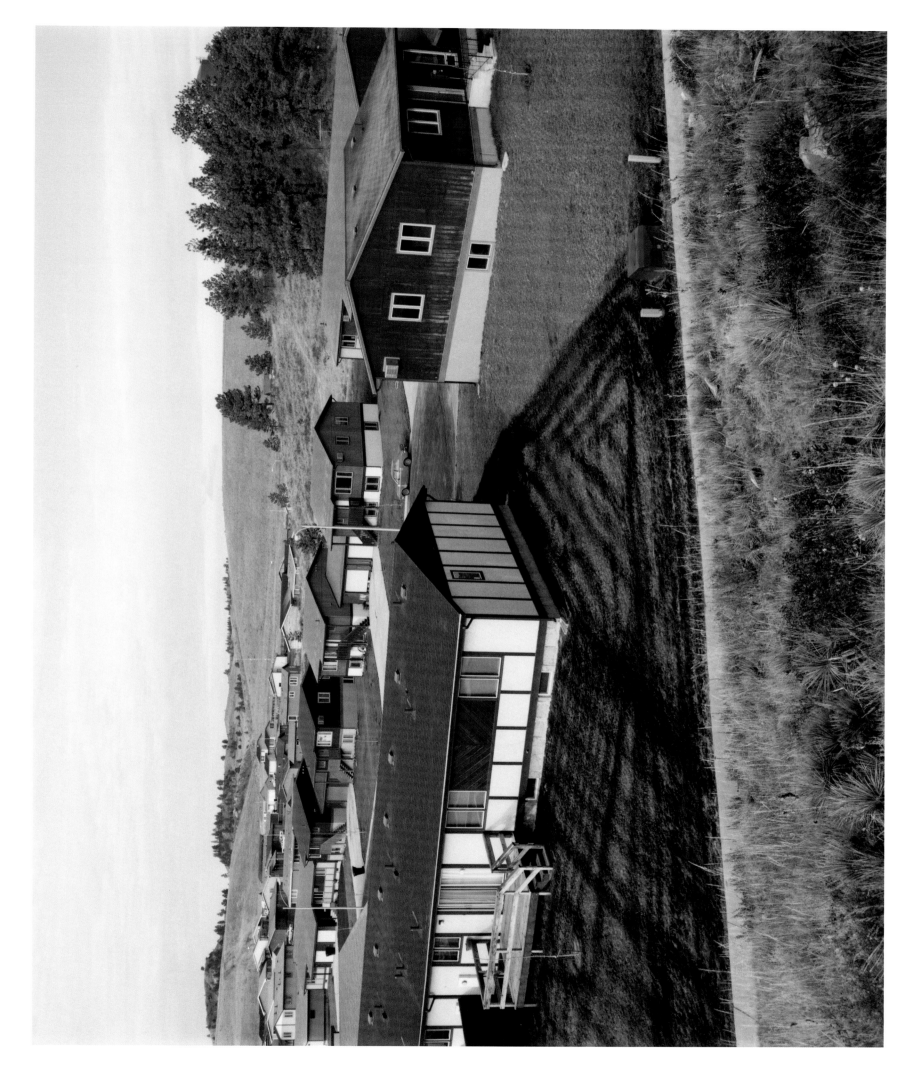

15 View from First Baptist Church of Colstrip: company houses and power plant

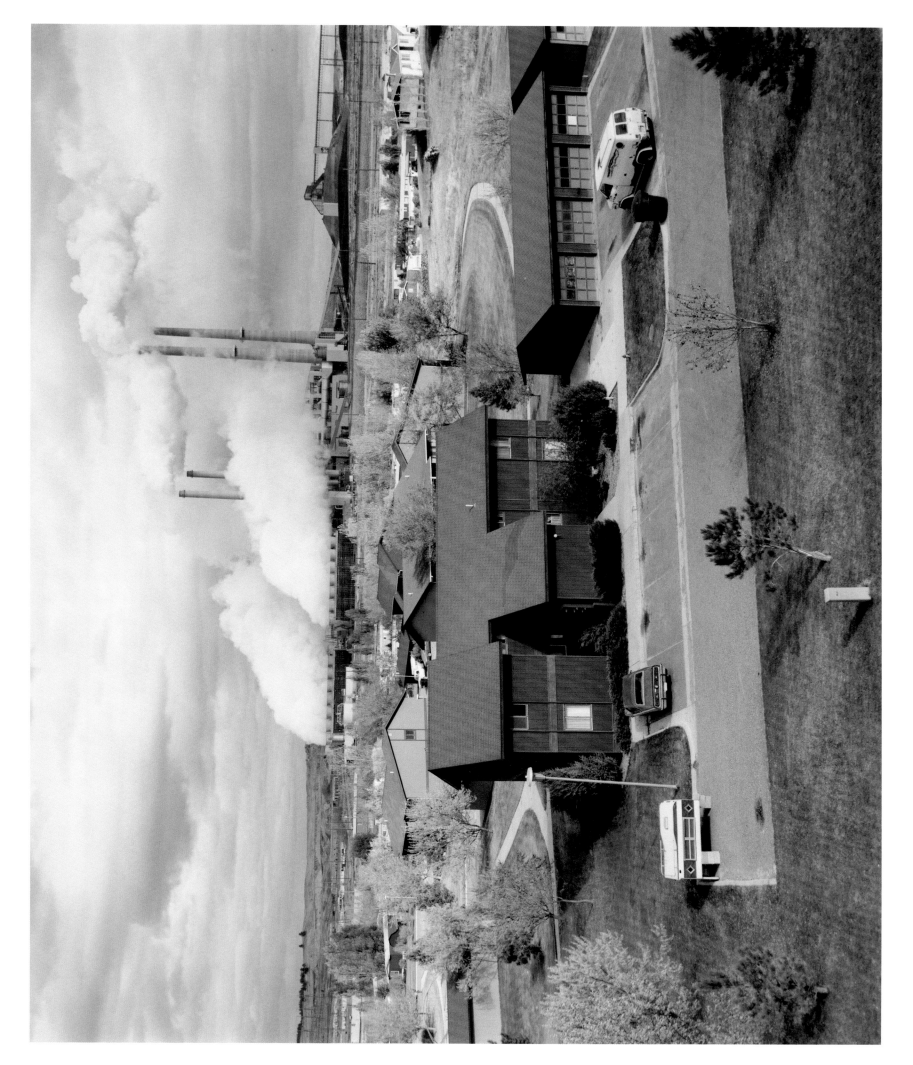

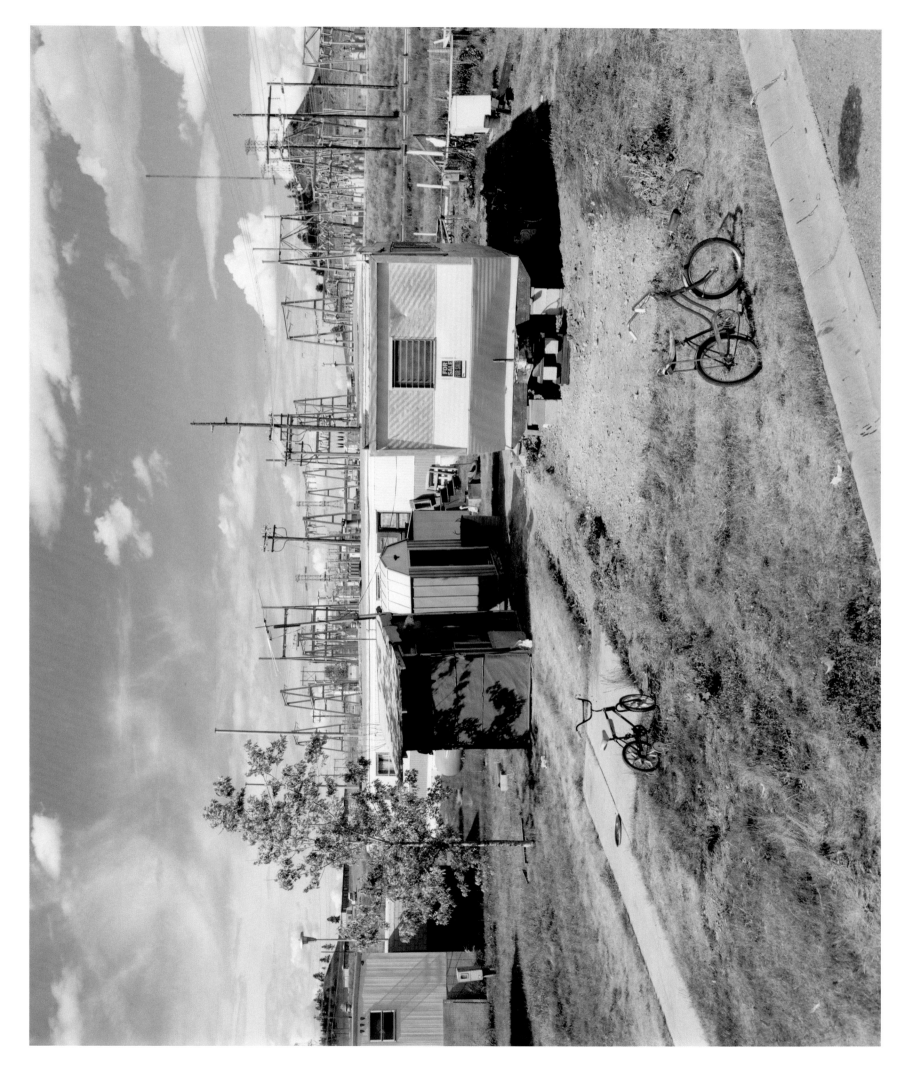

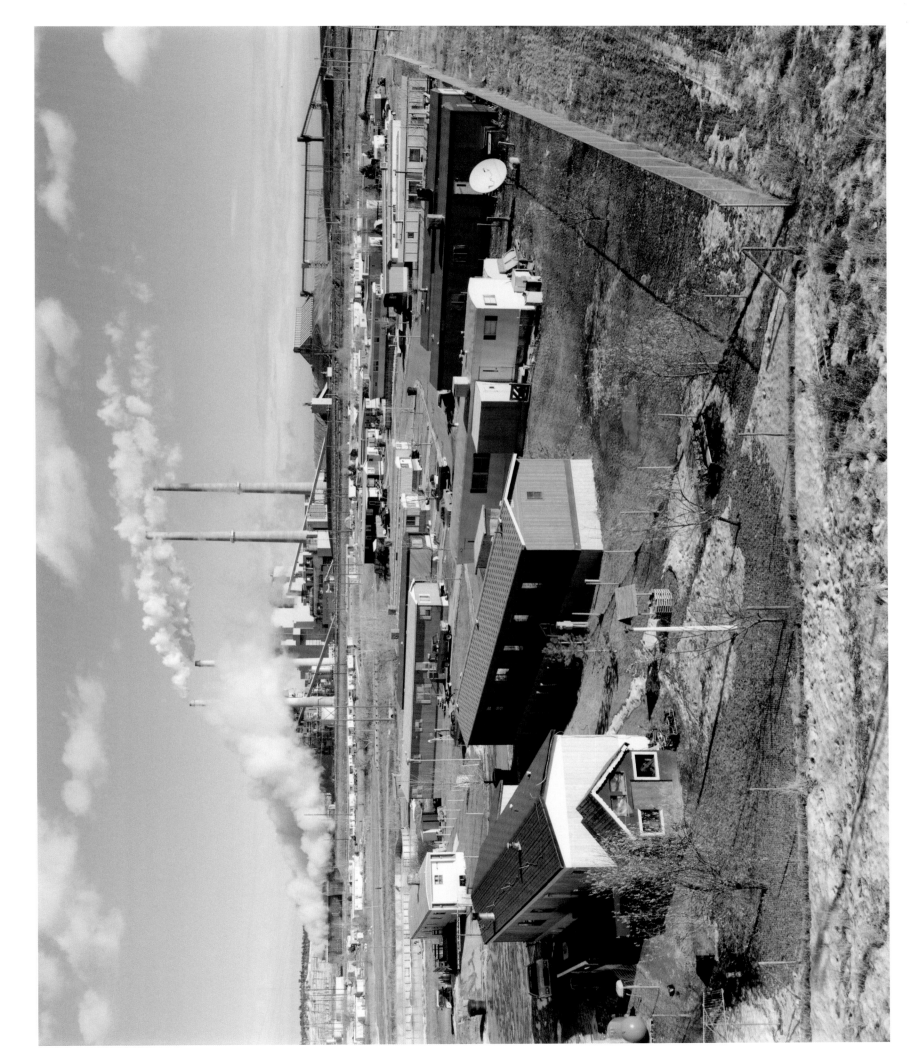

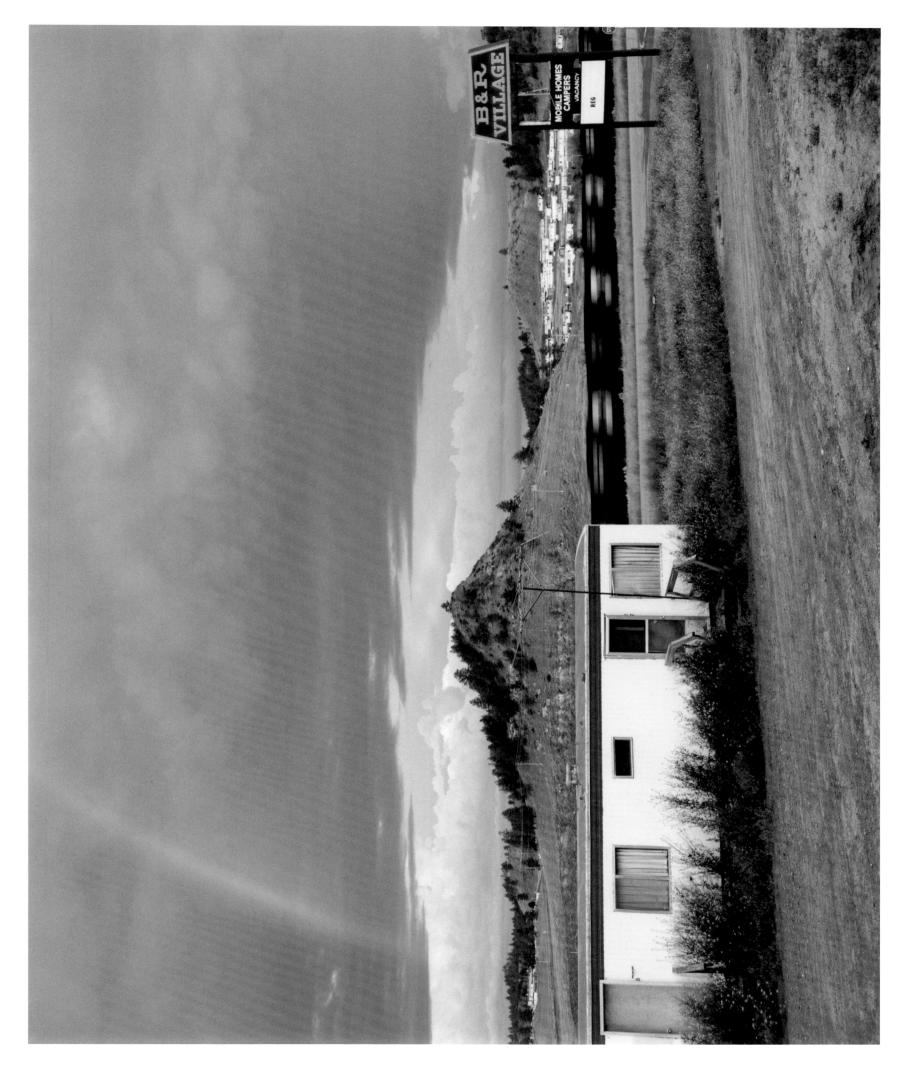

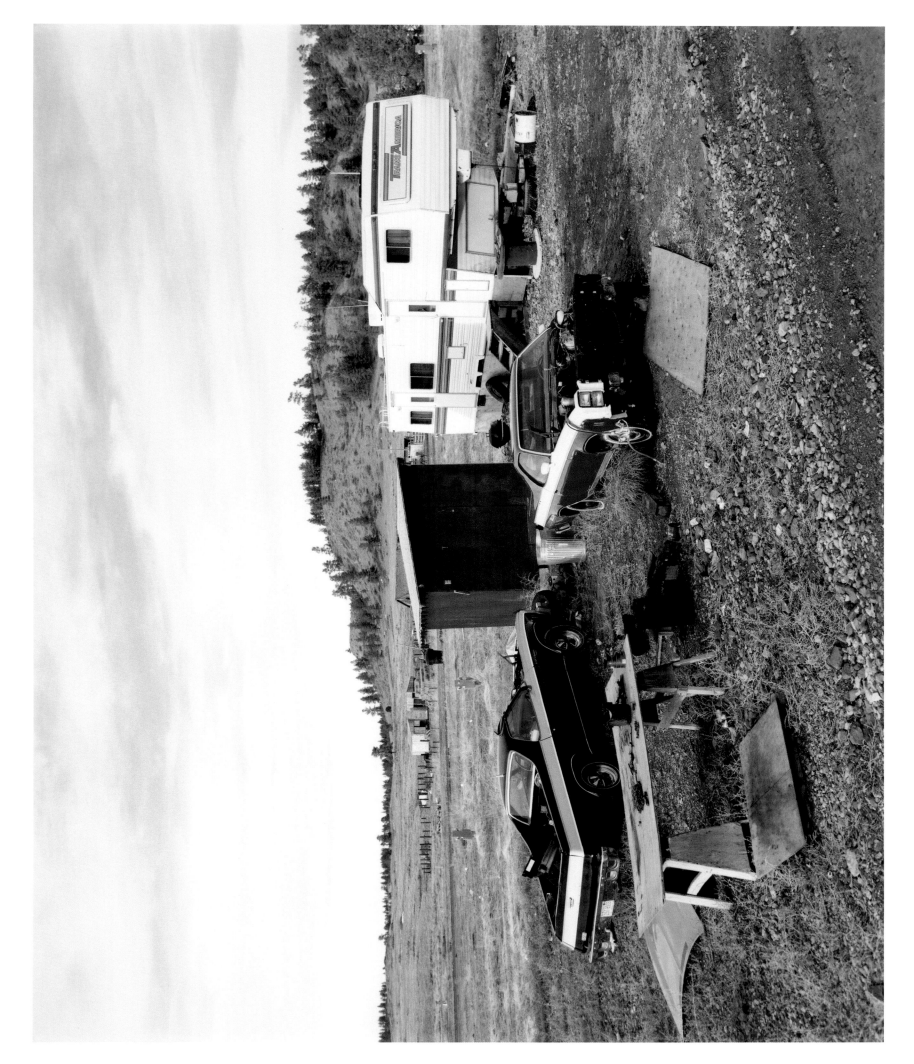

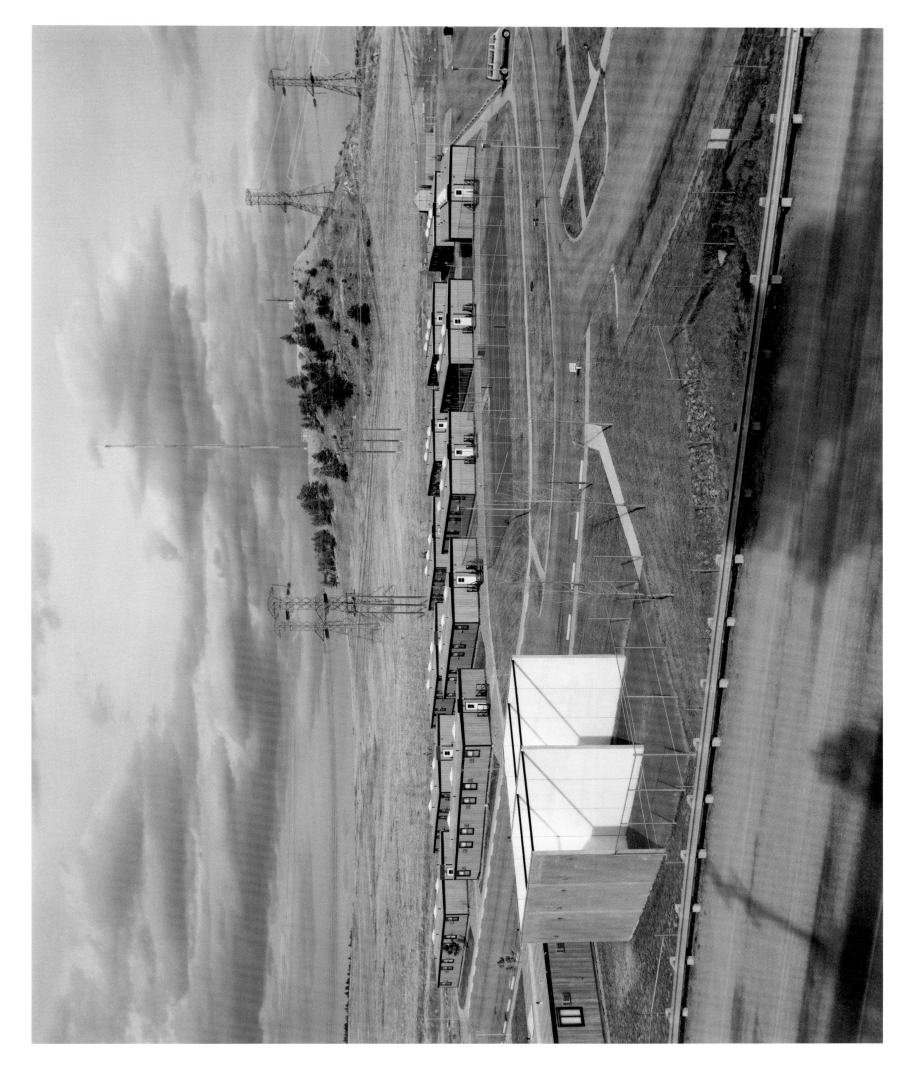

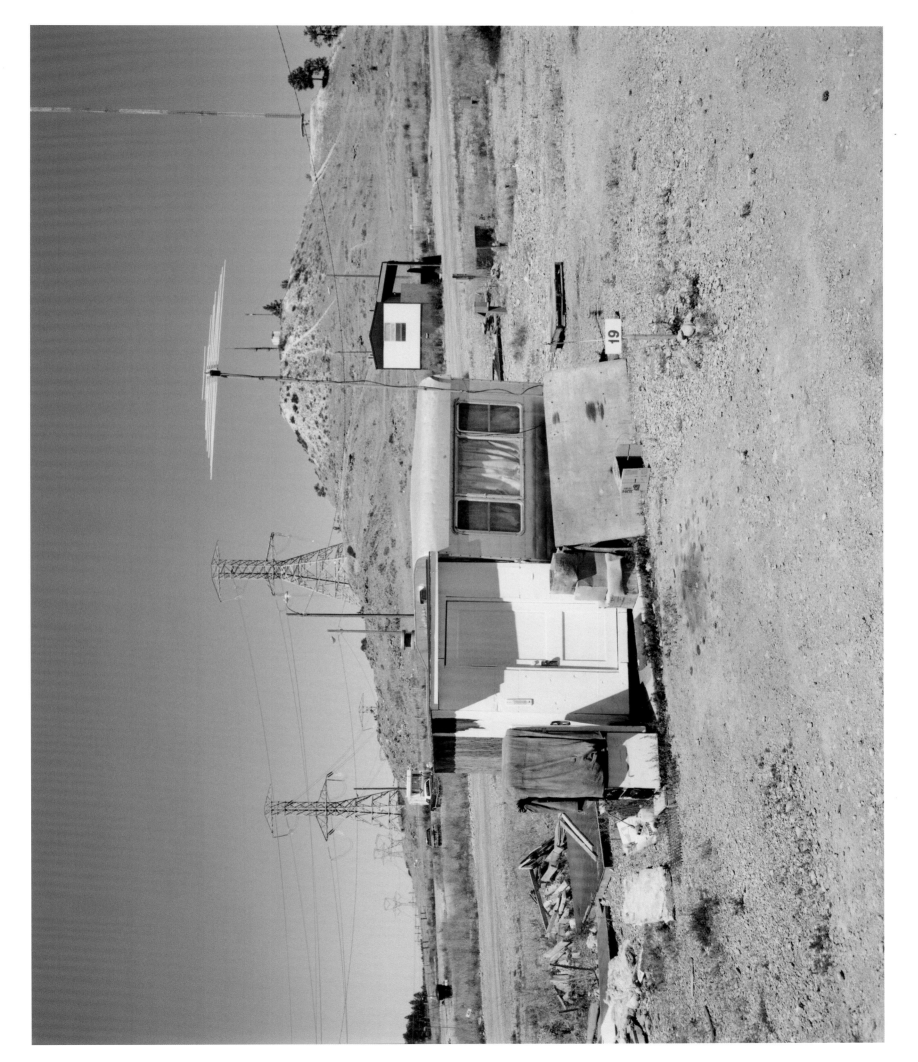

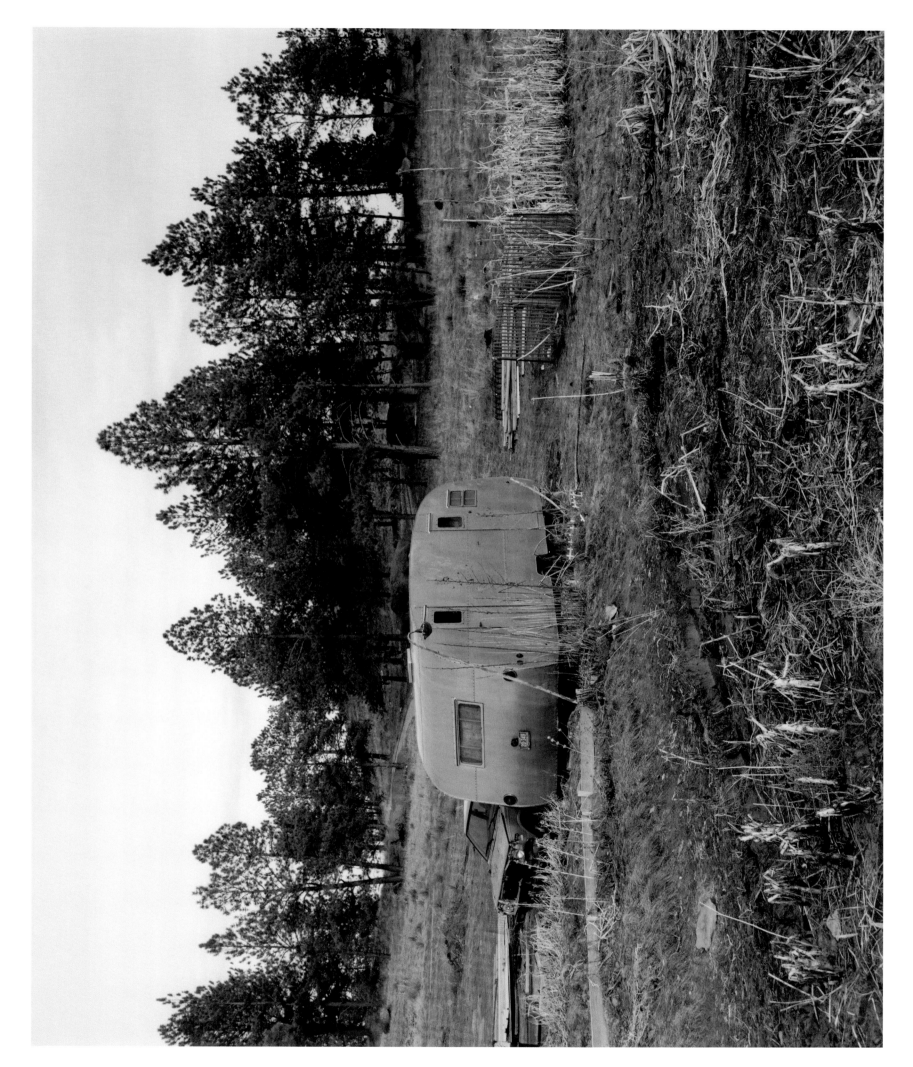

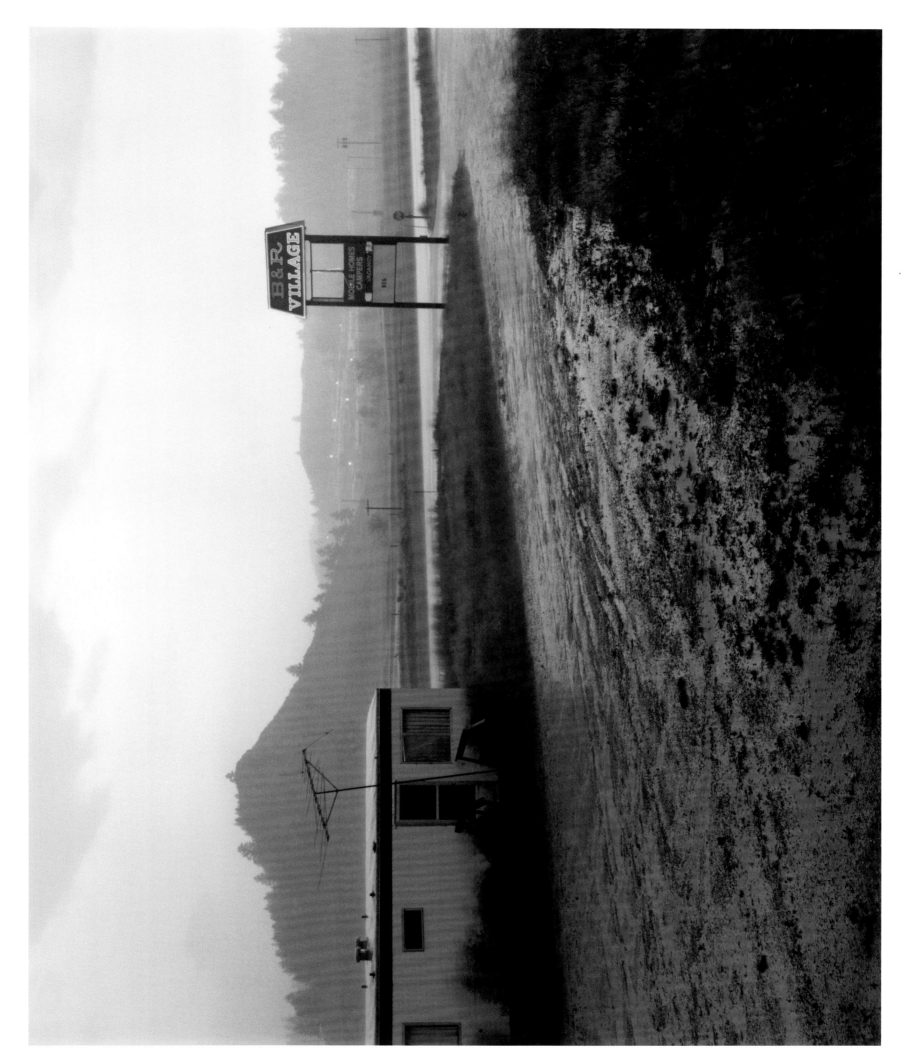

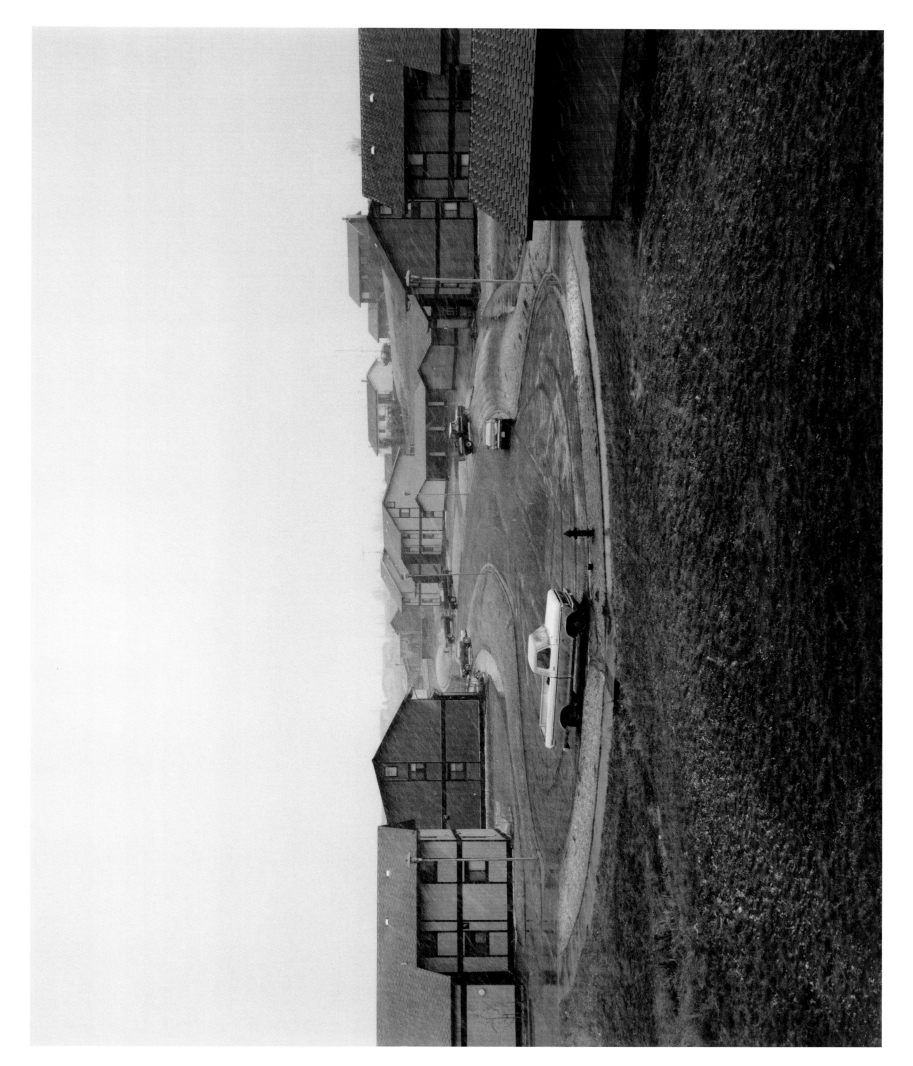

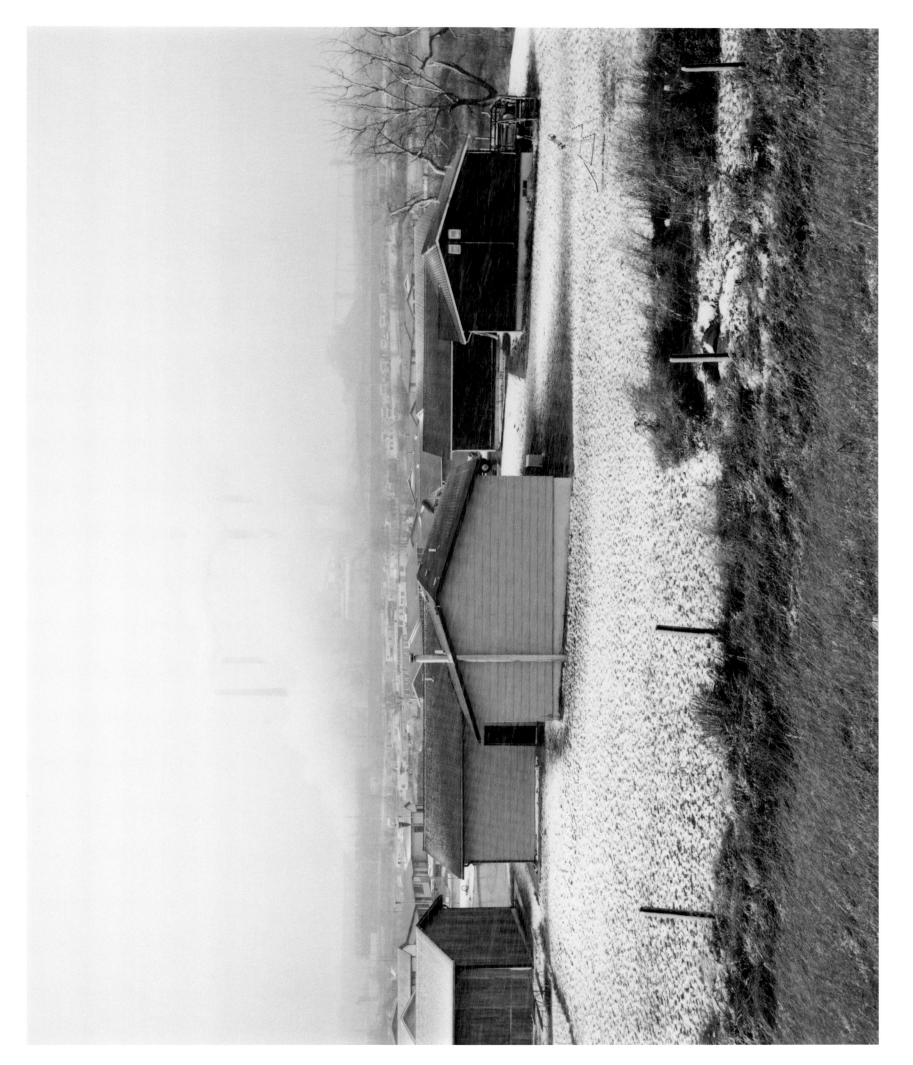

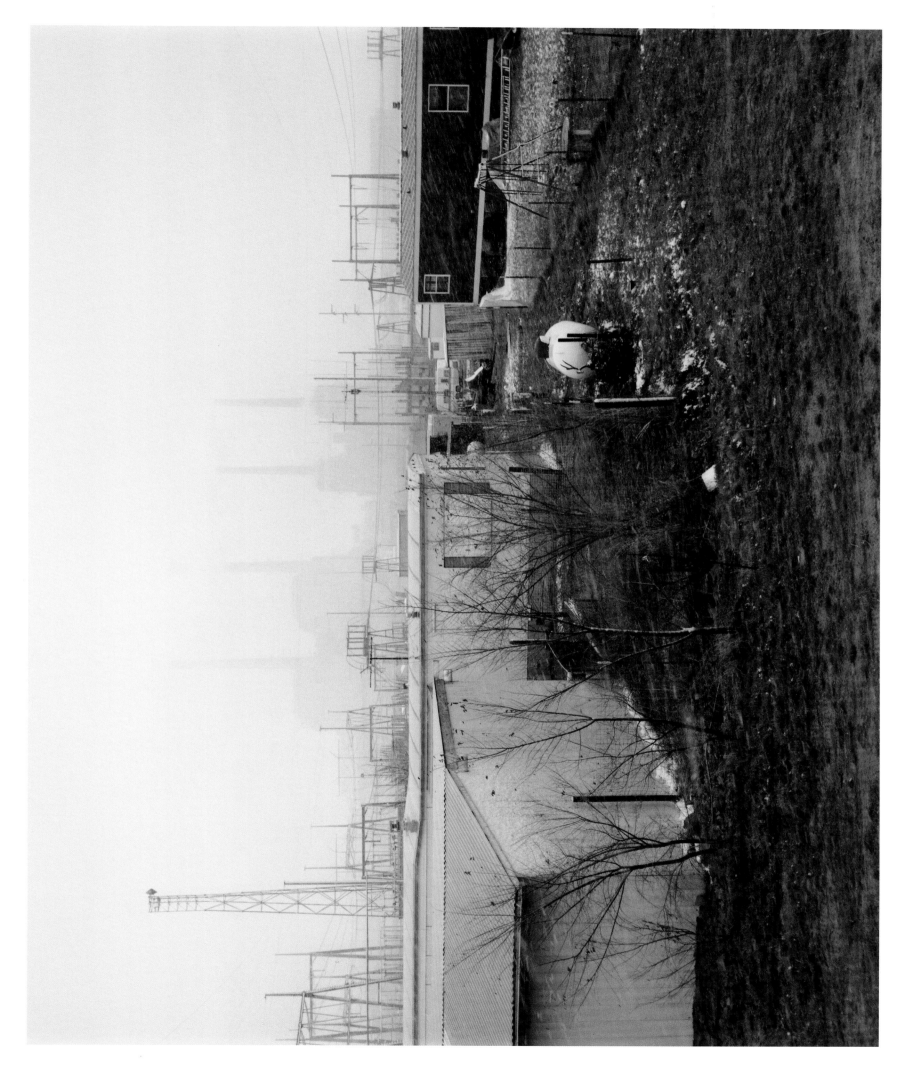

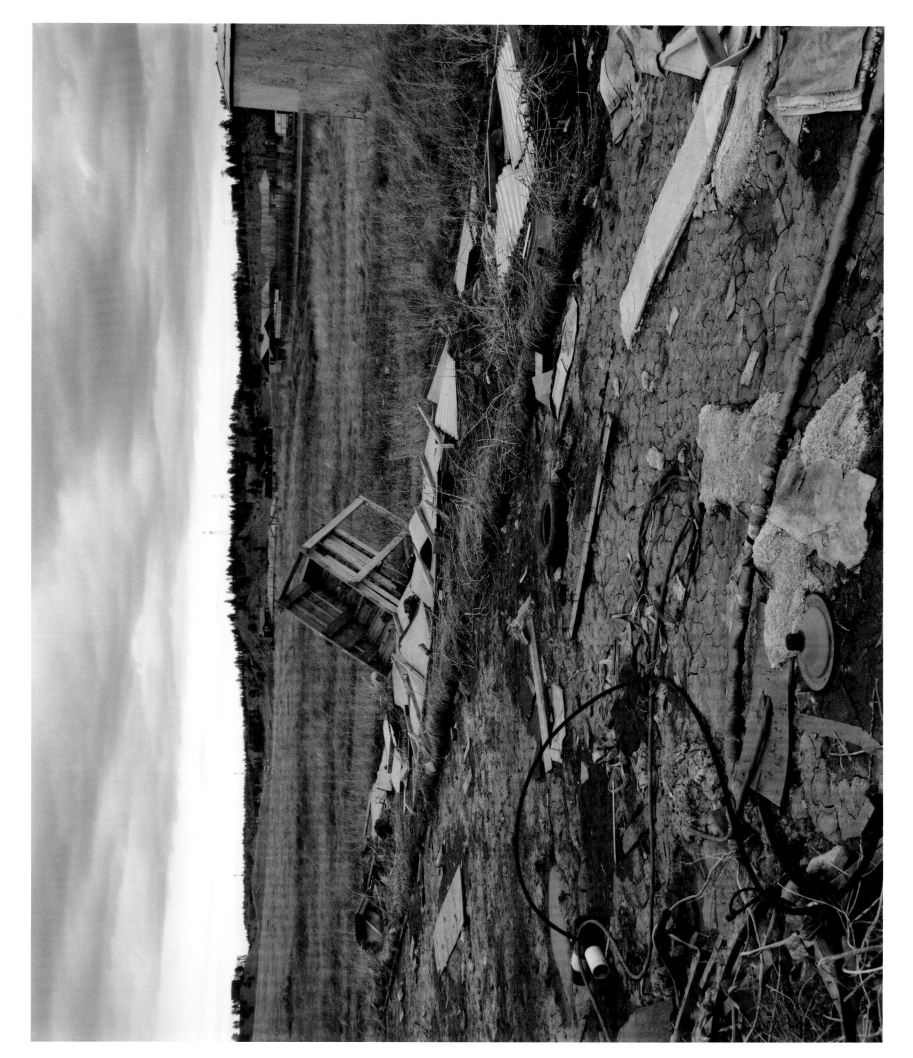

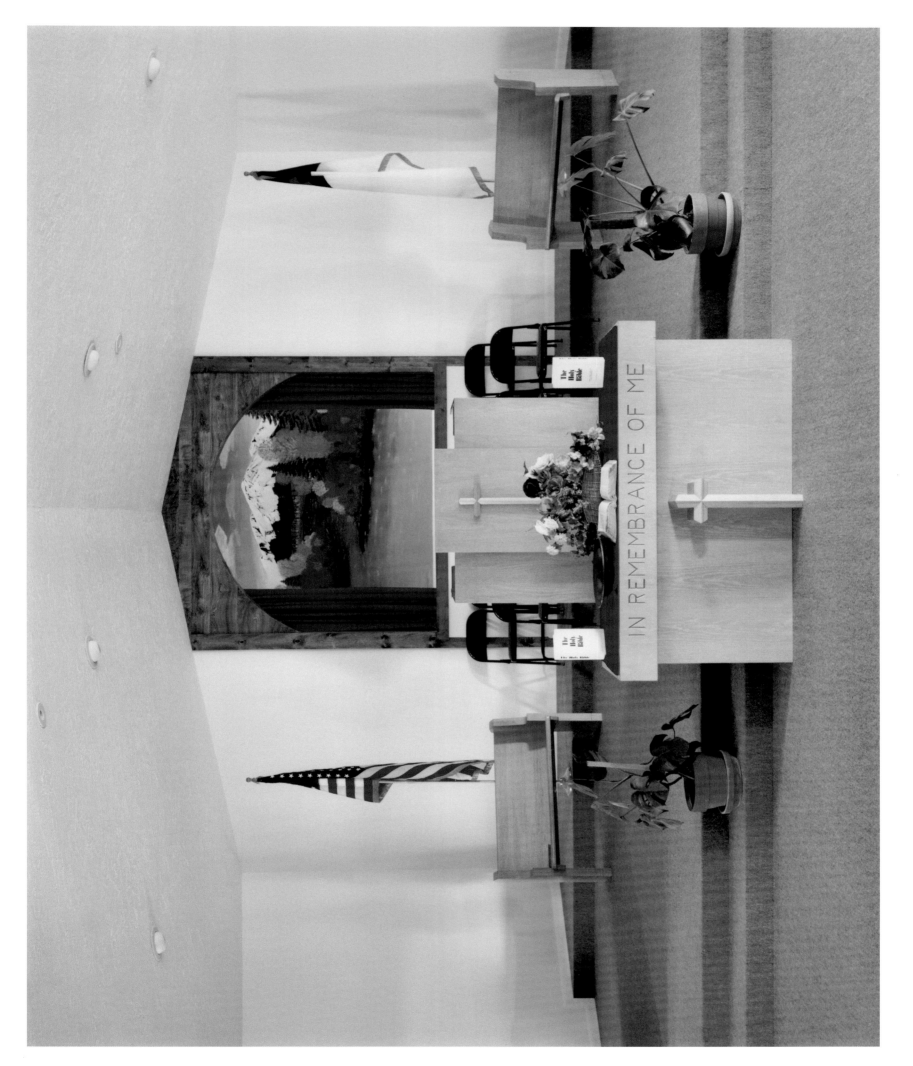

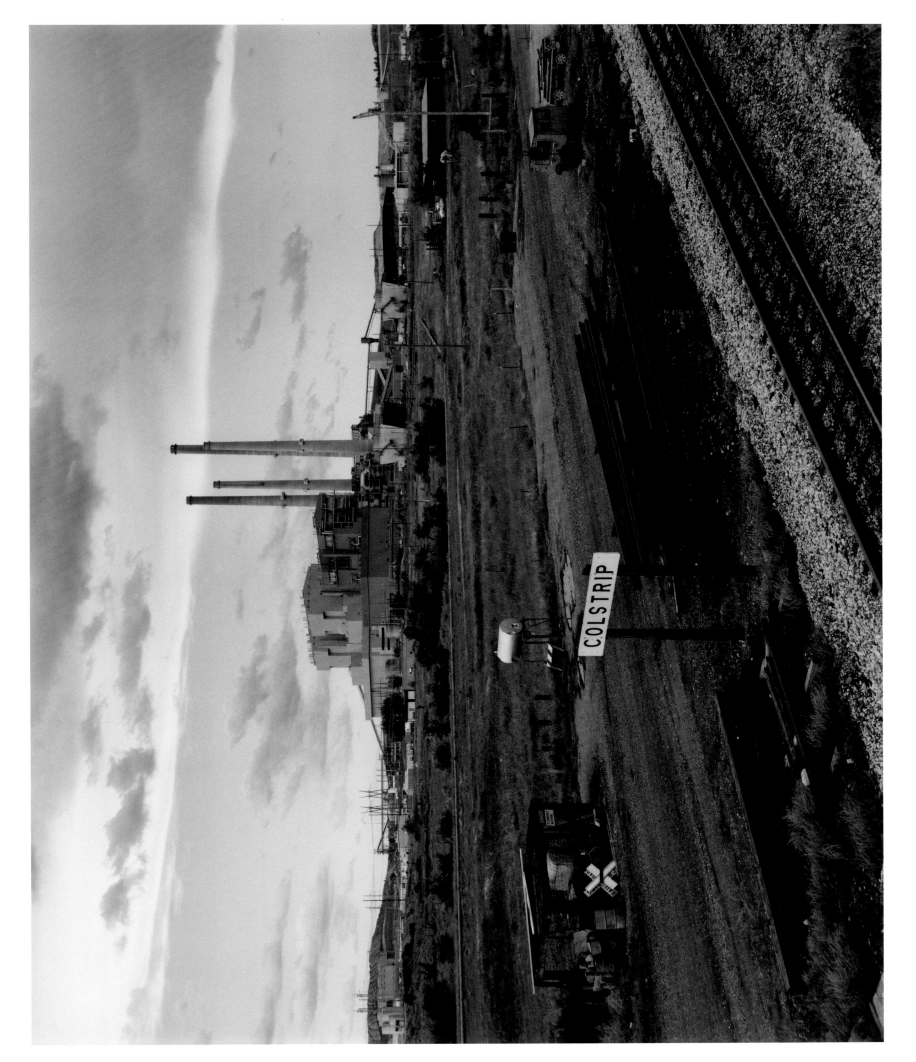

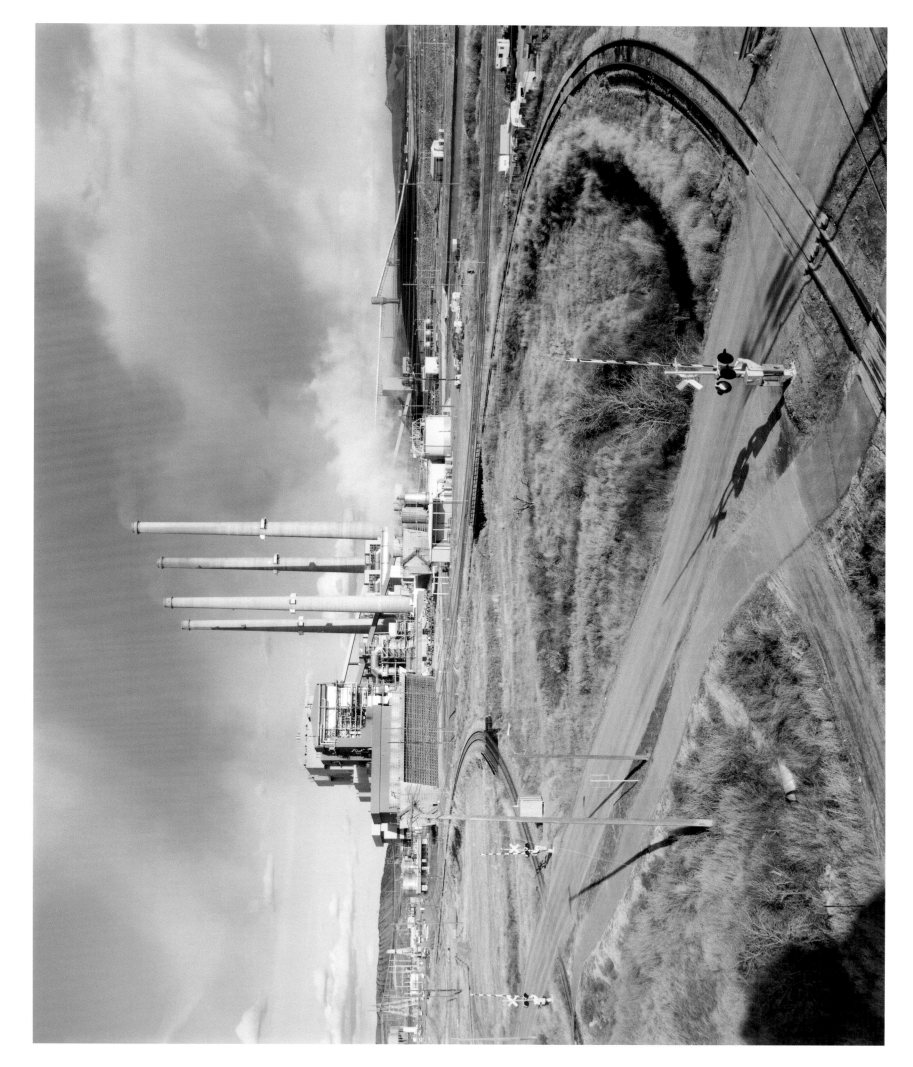

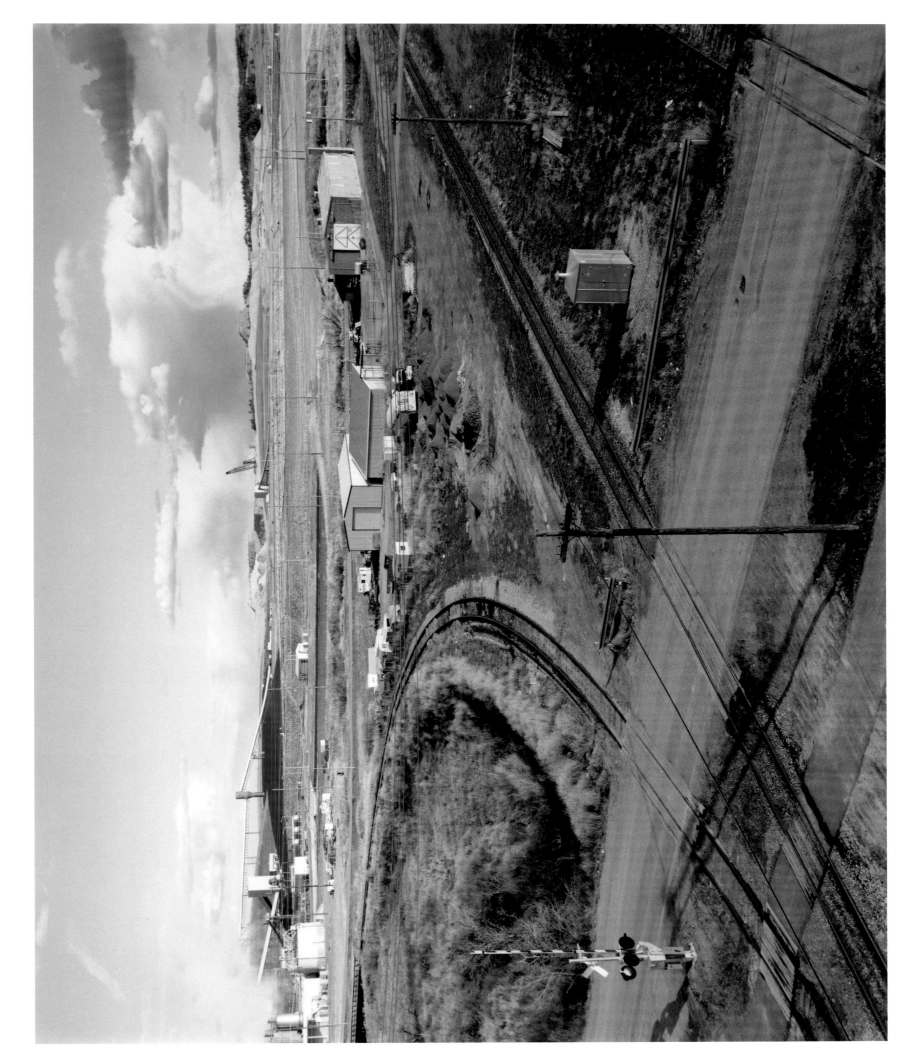

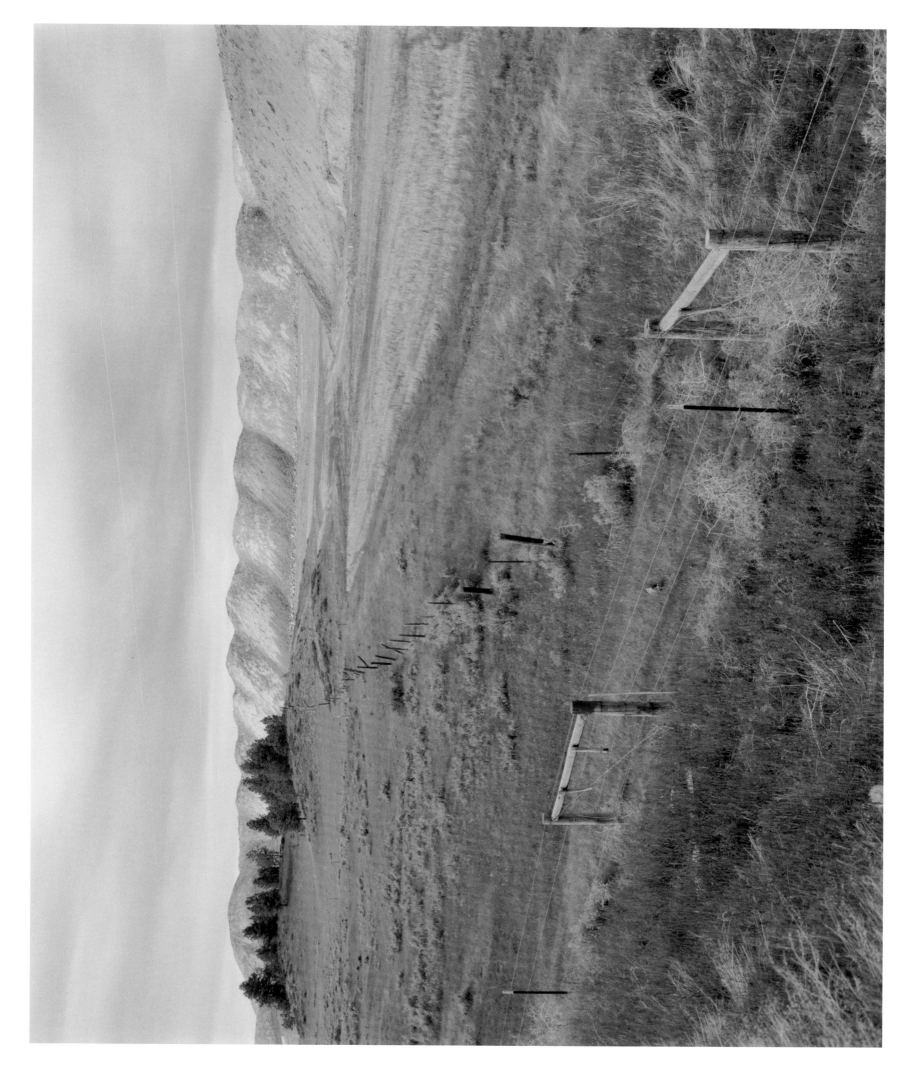

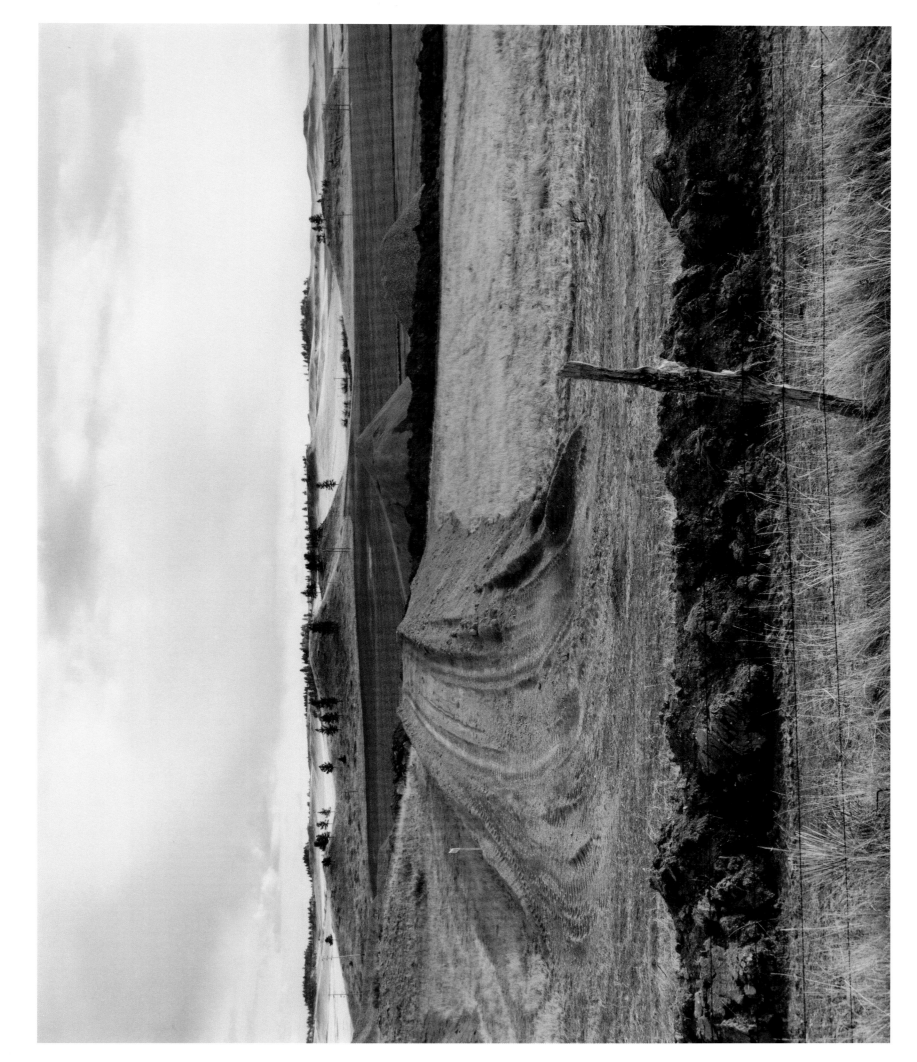

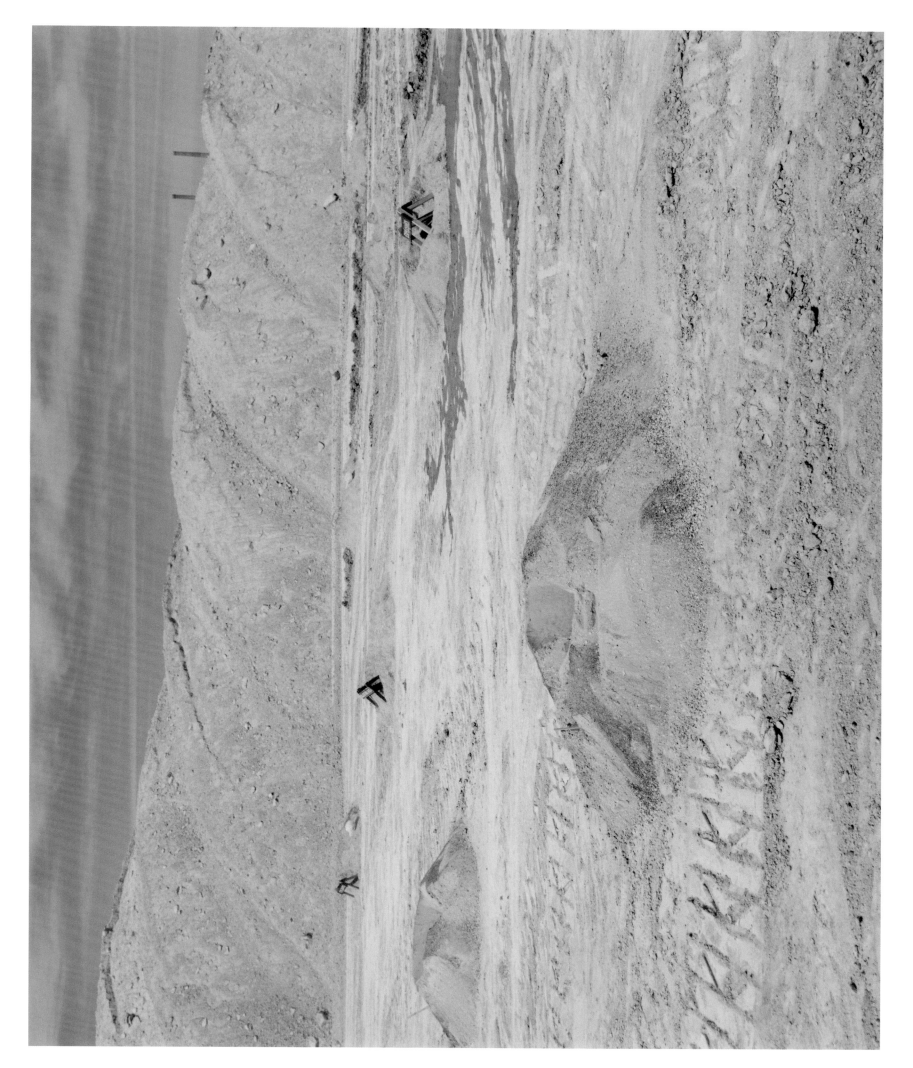

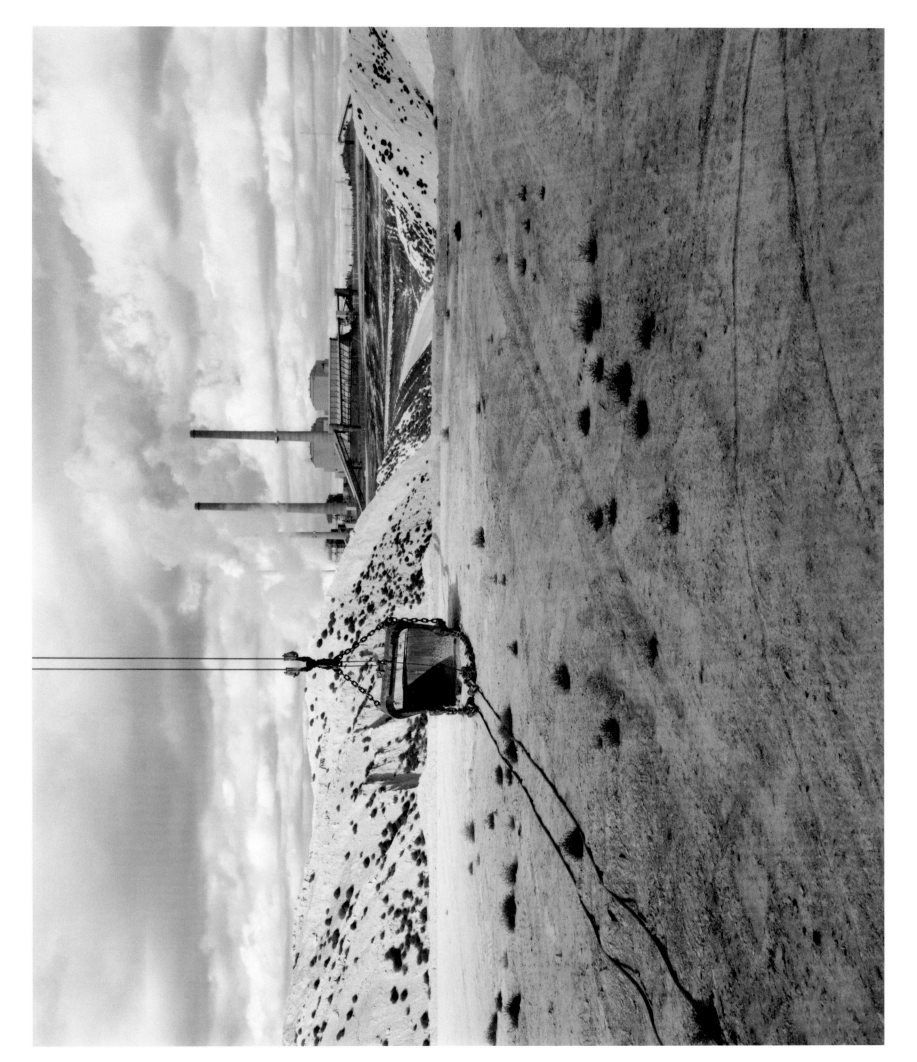

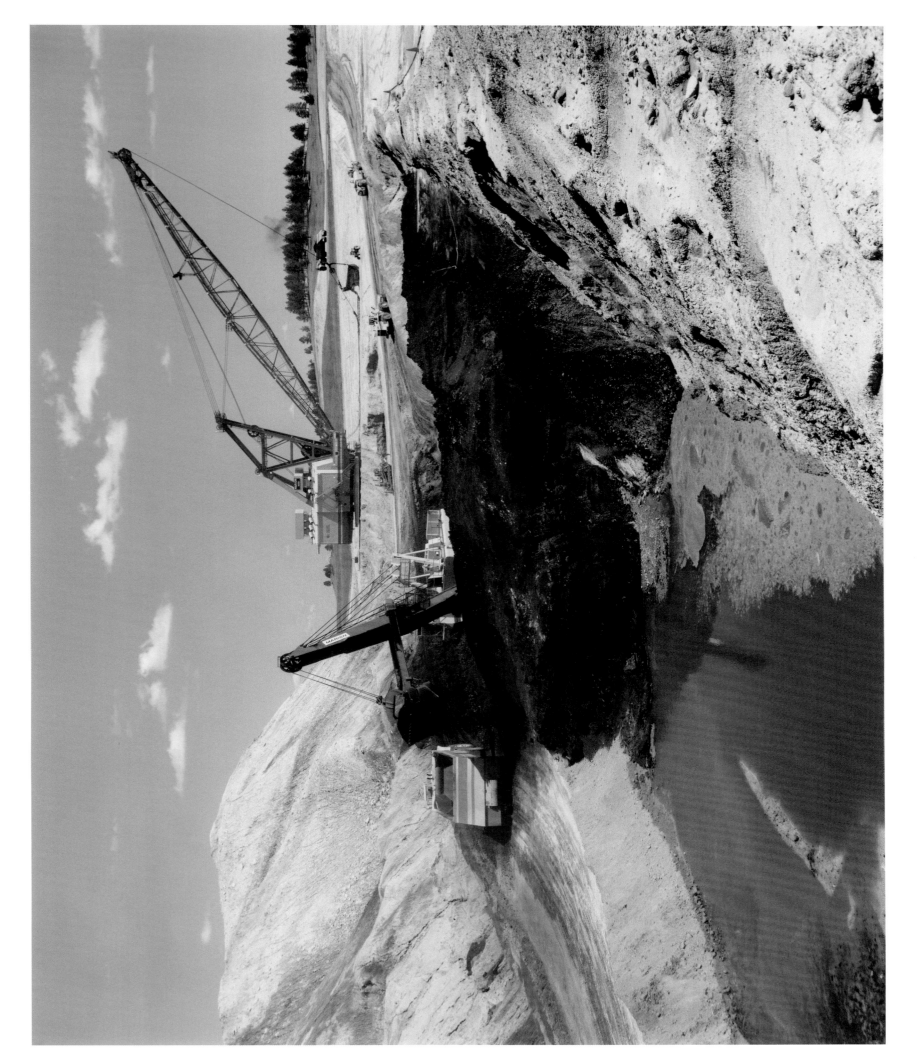

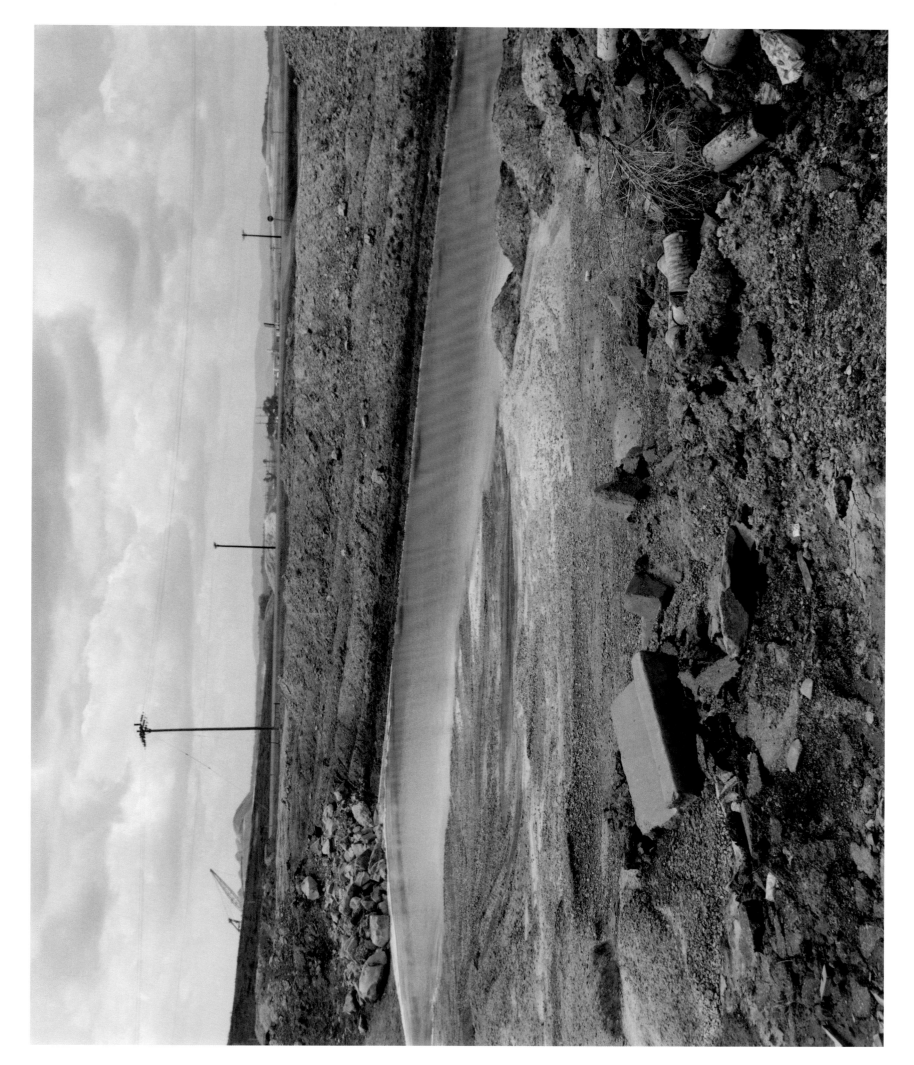

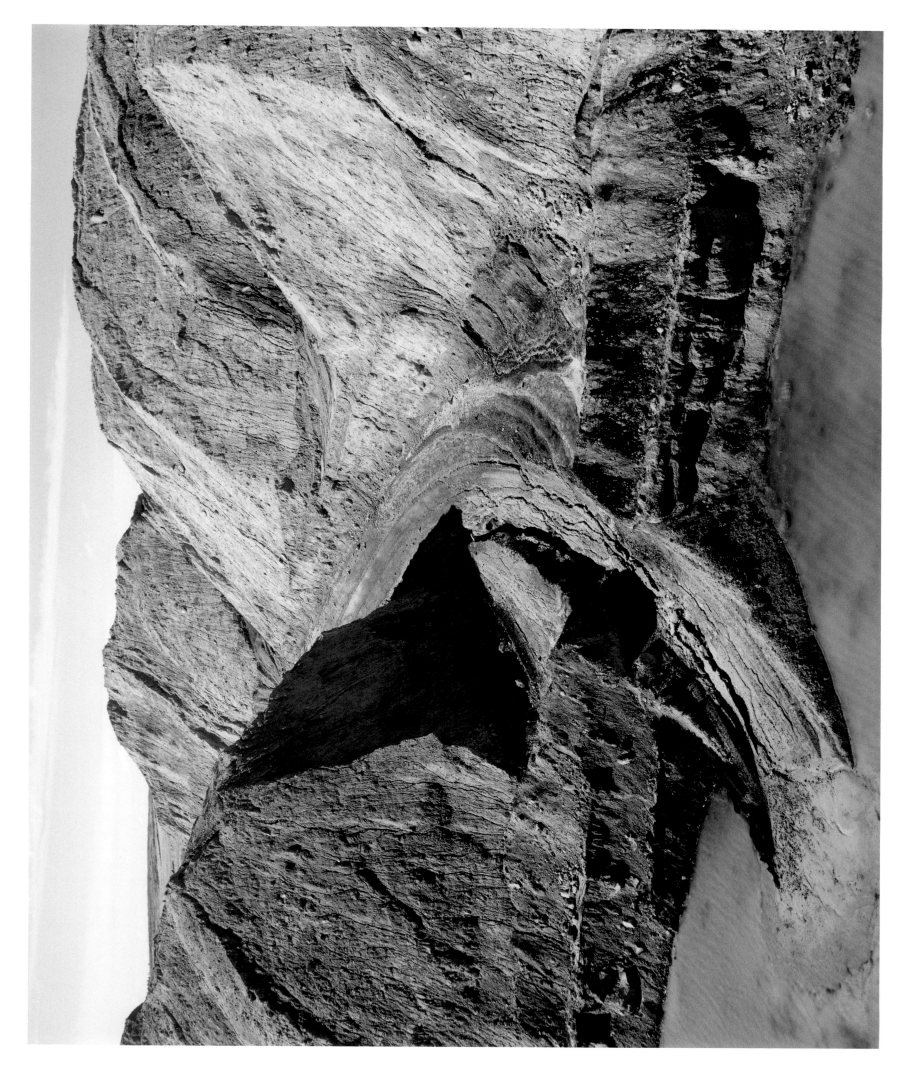

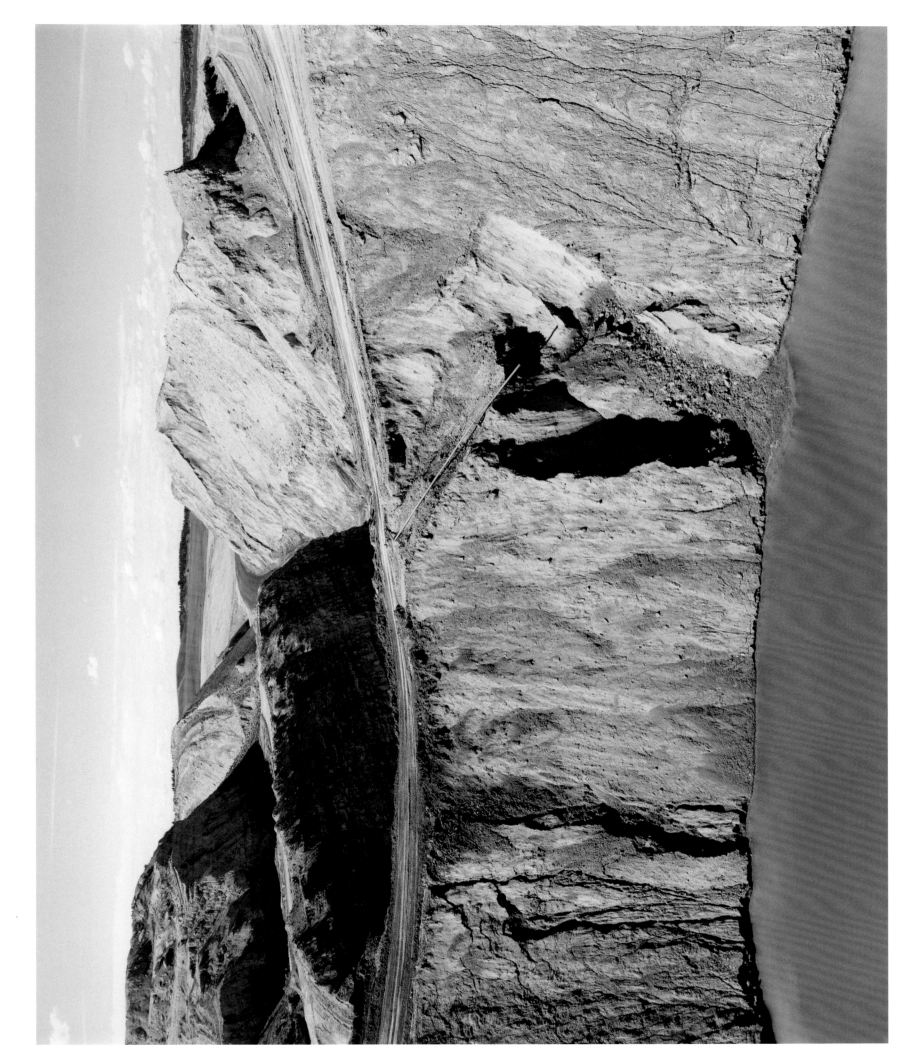

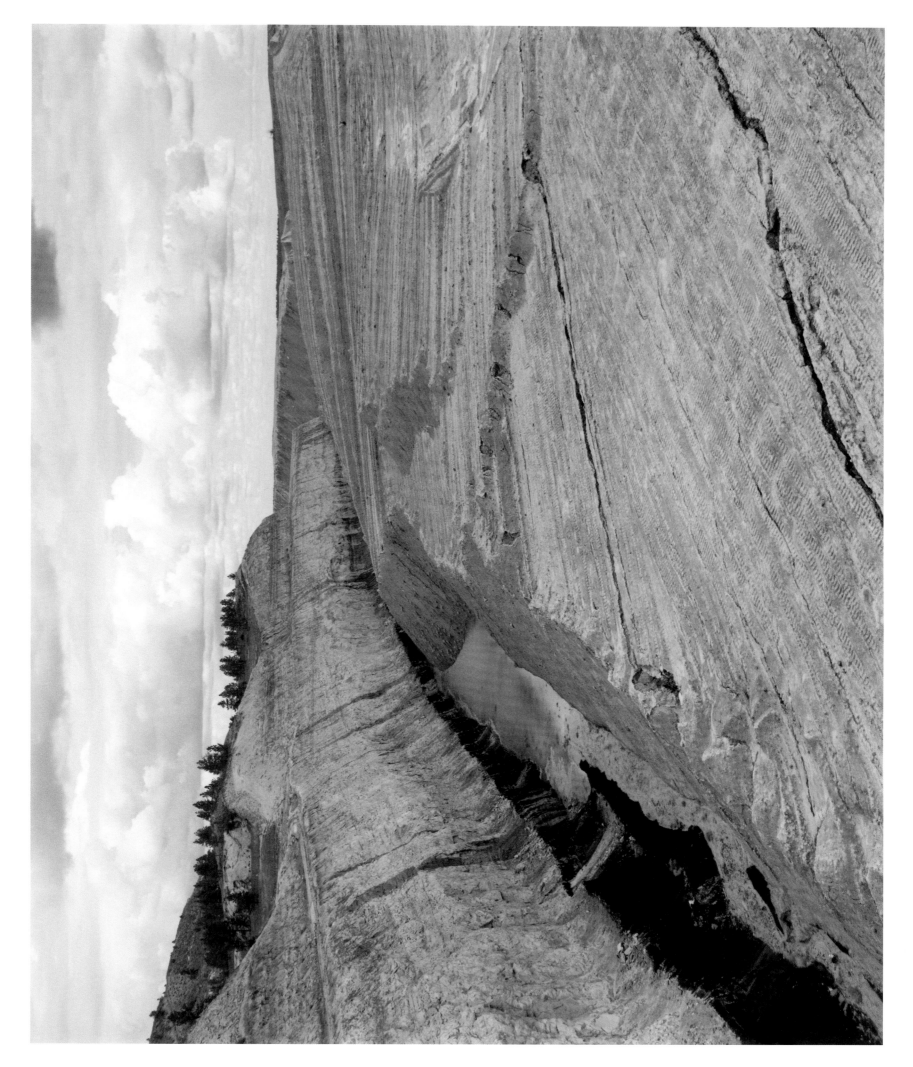

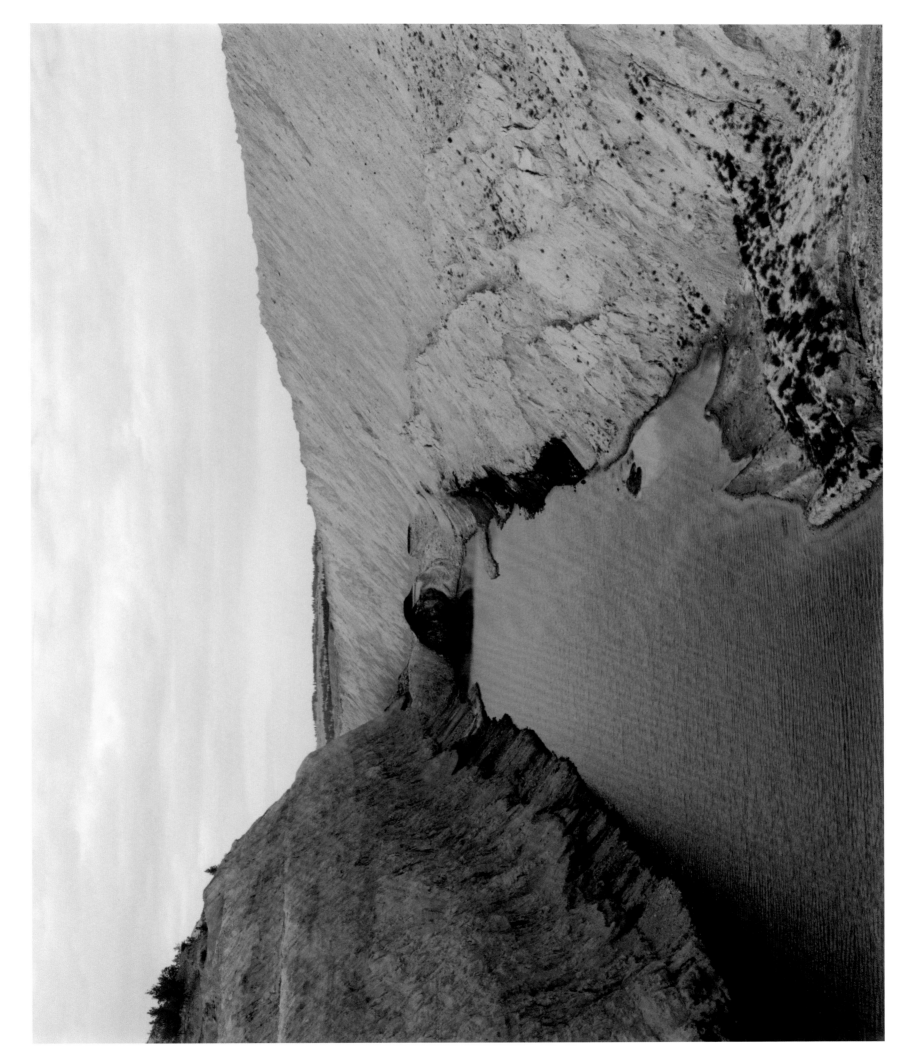

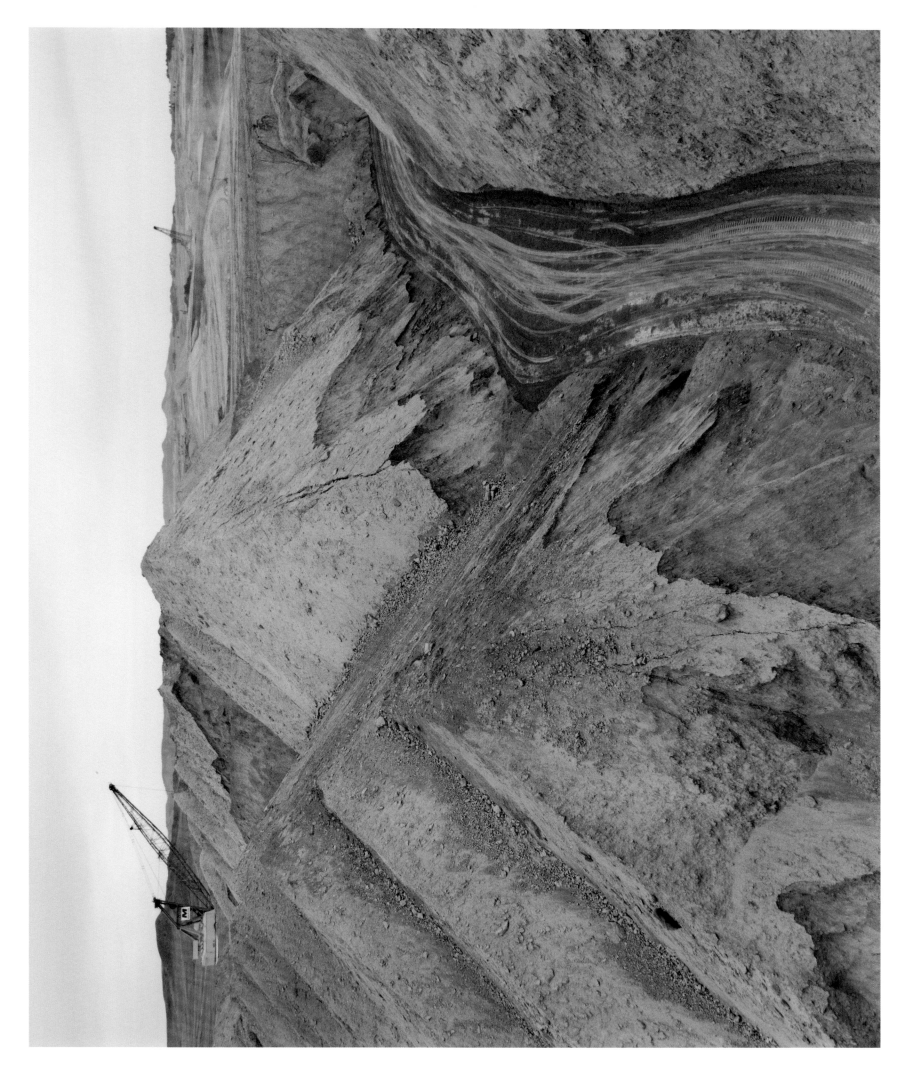

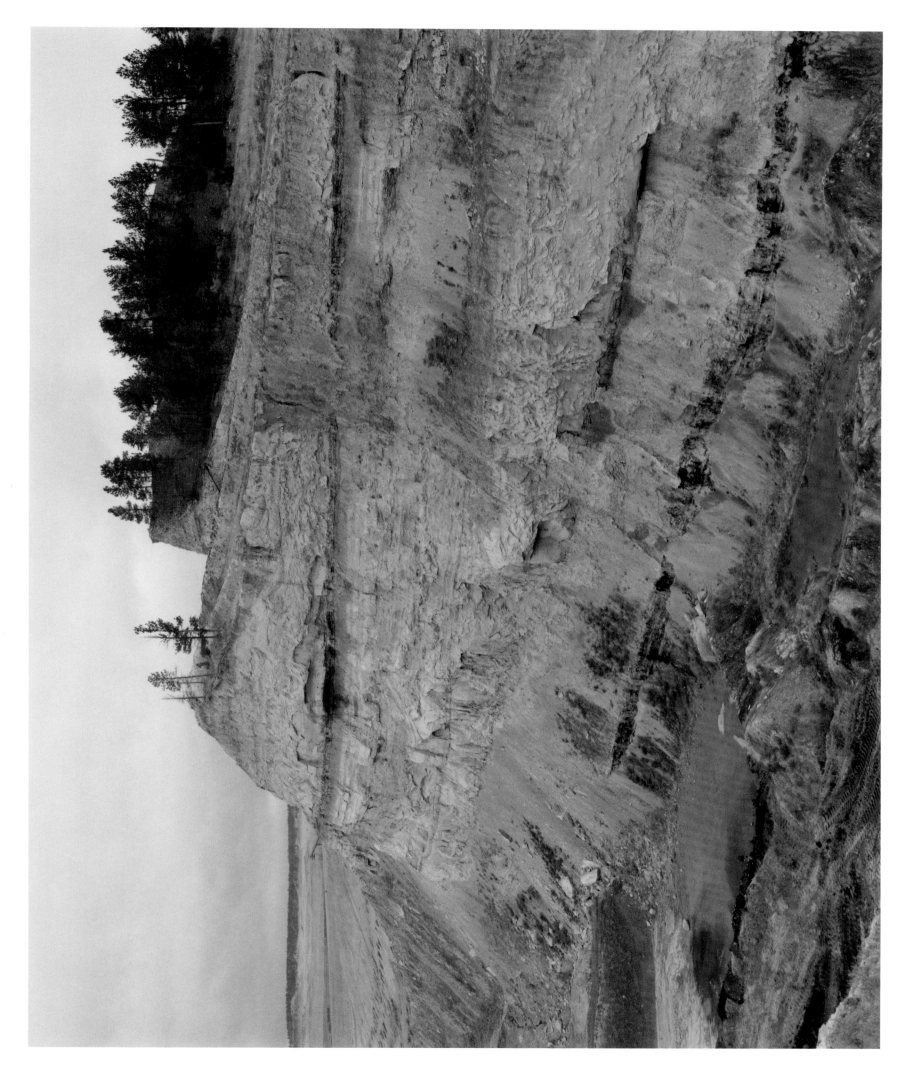

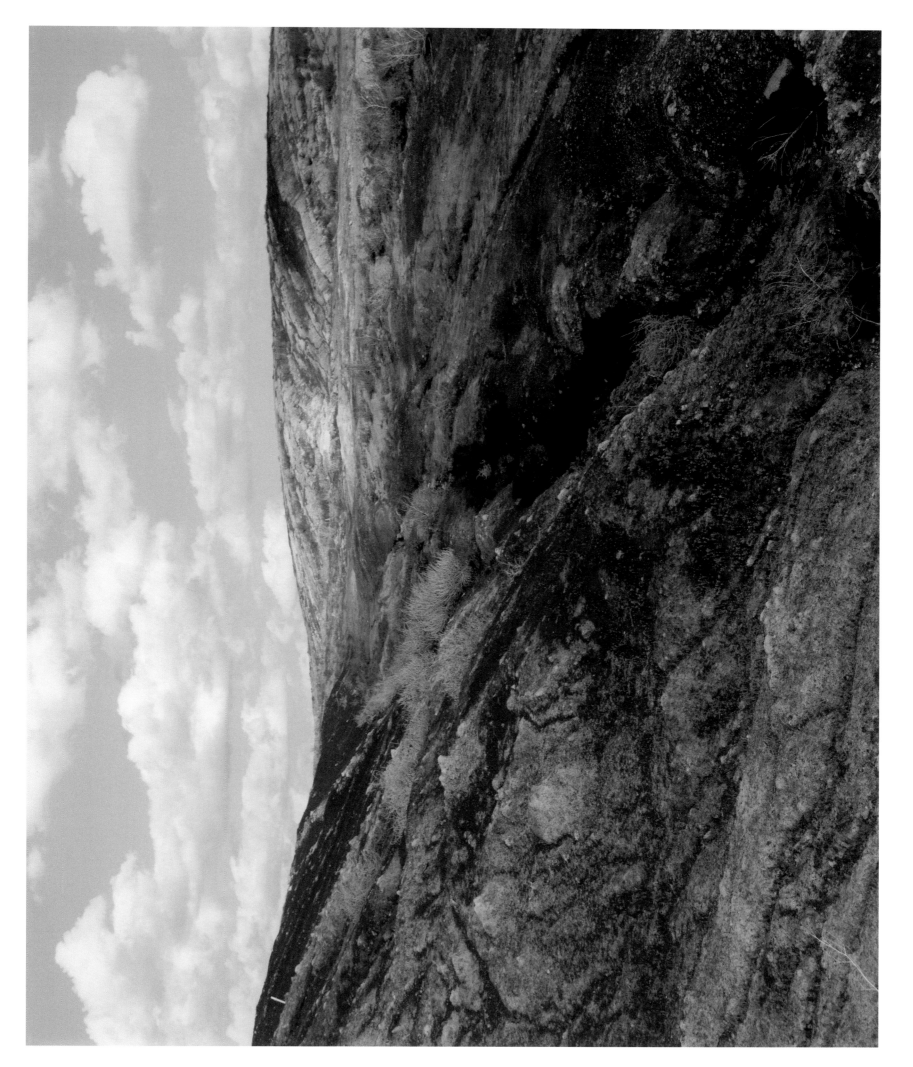

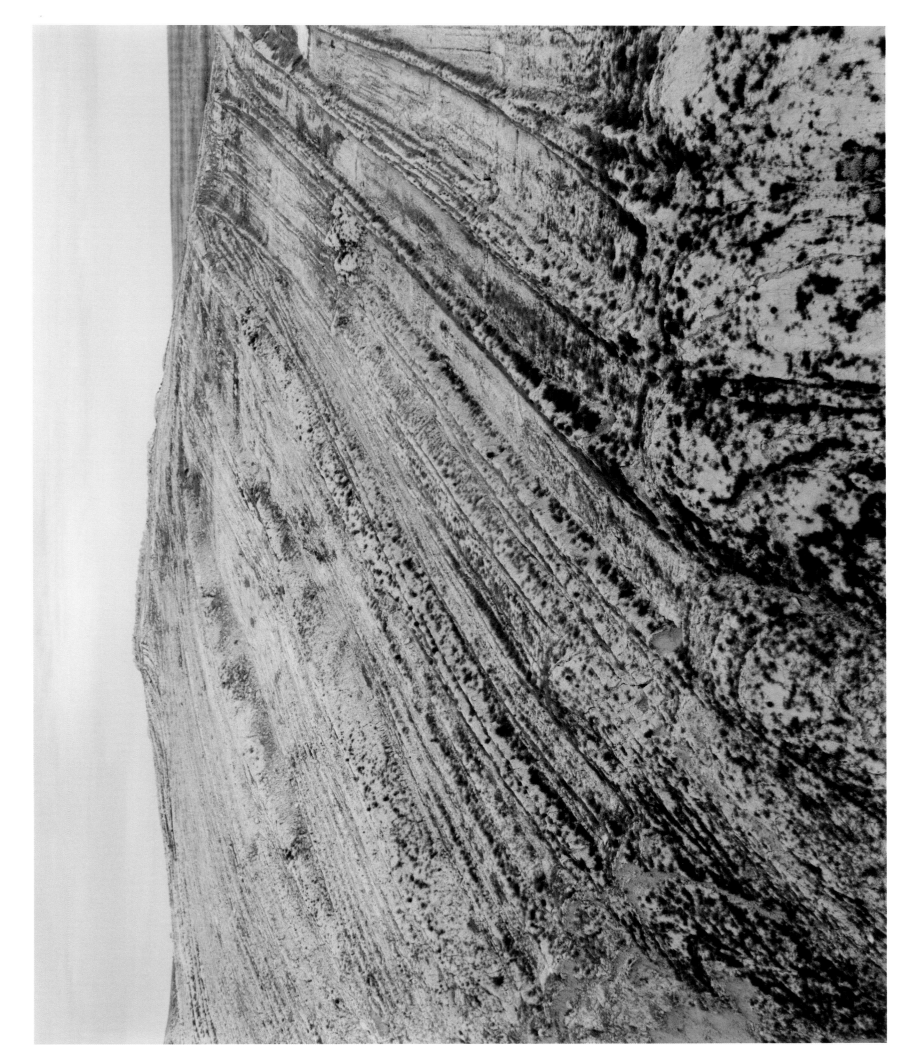

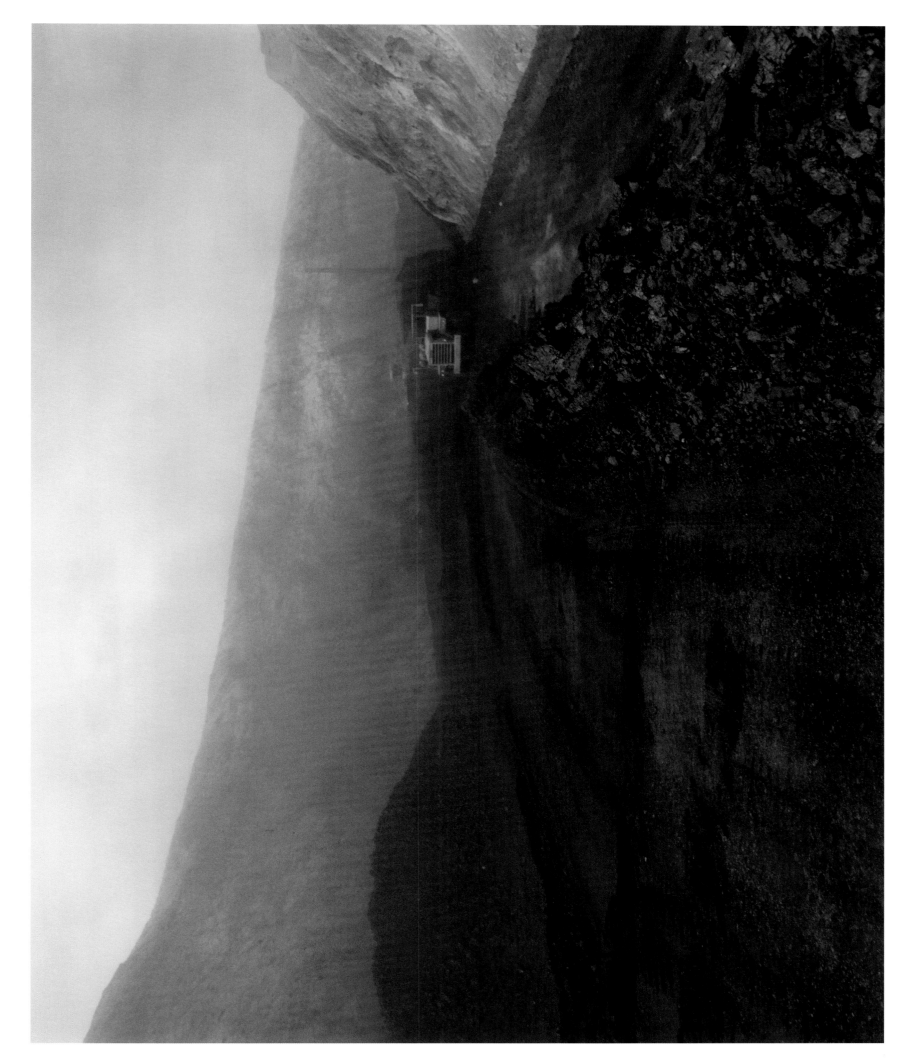

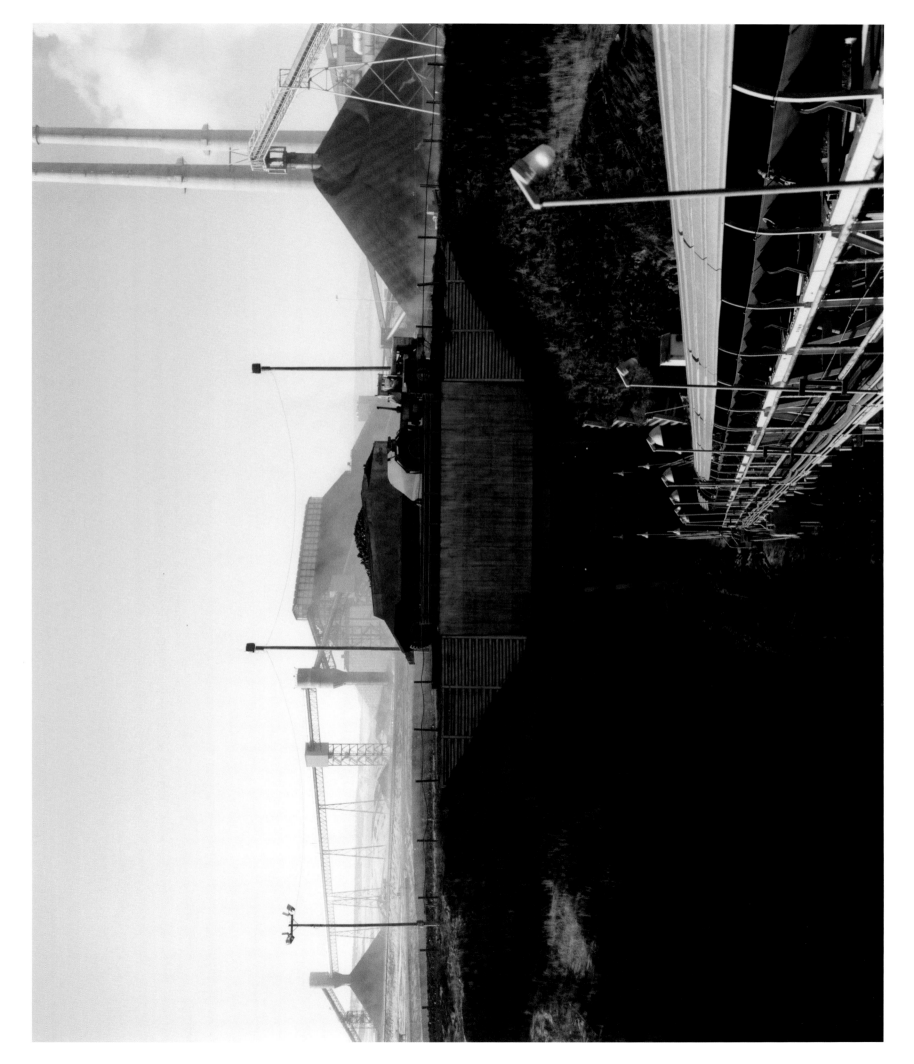

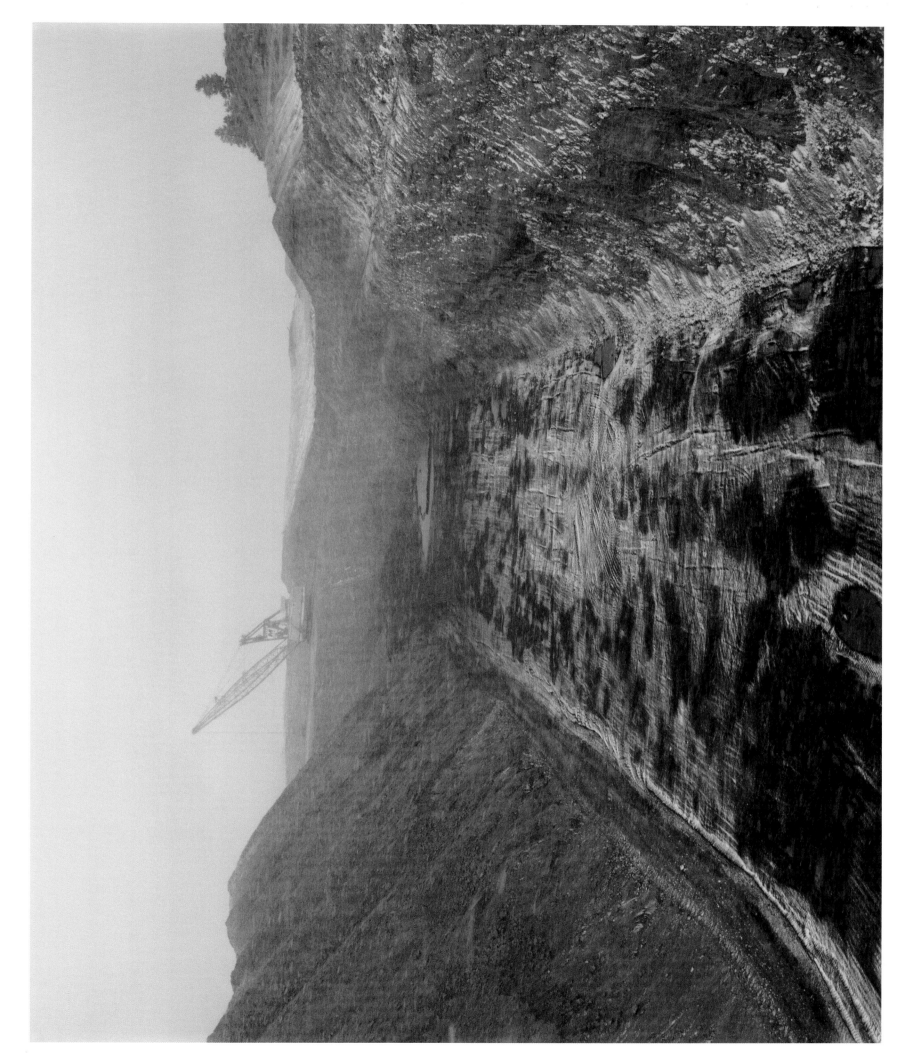

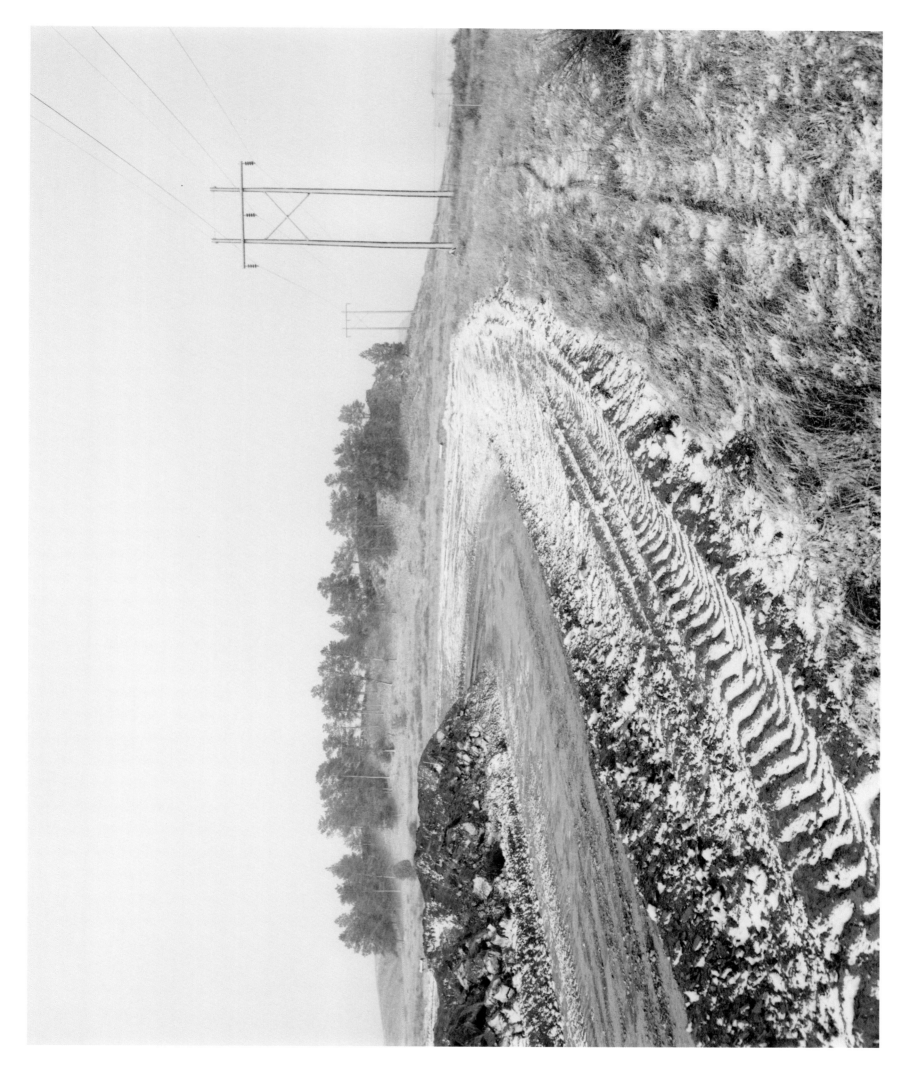

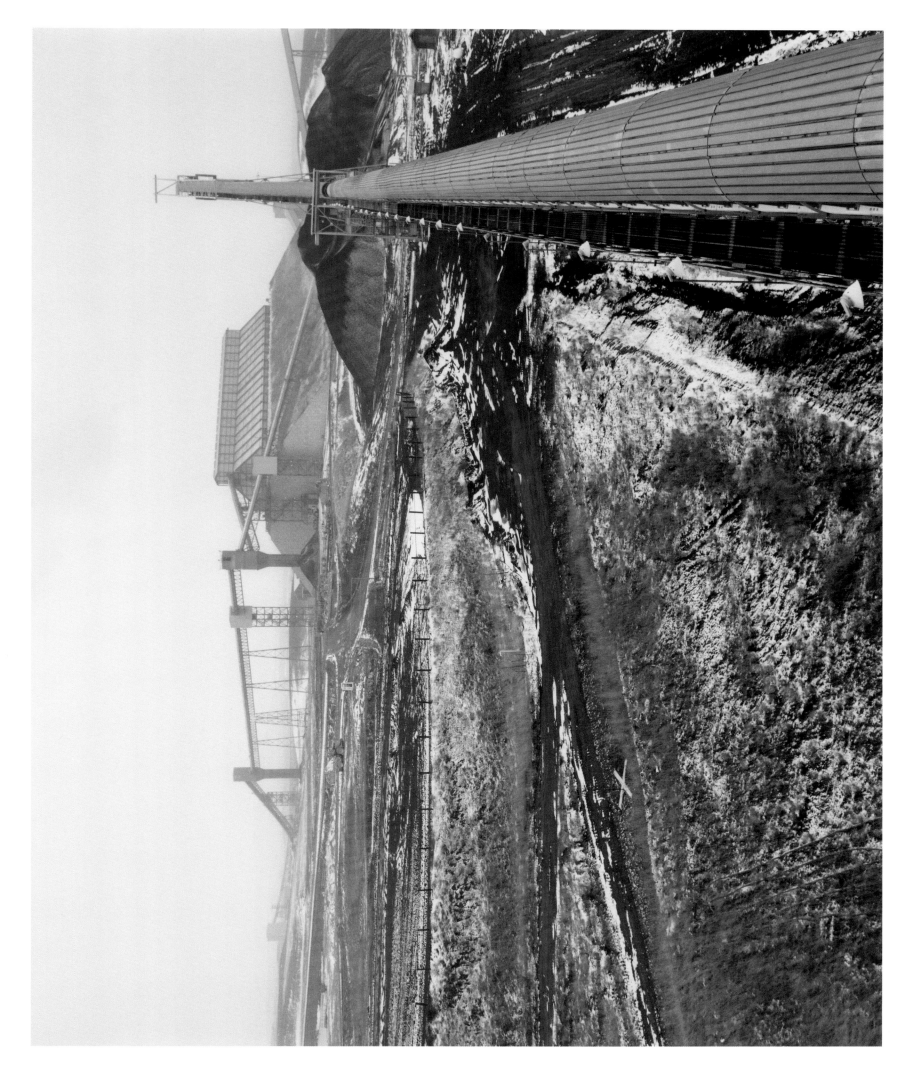

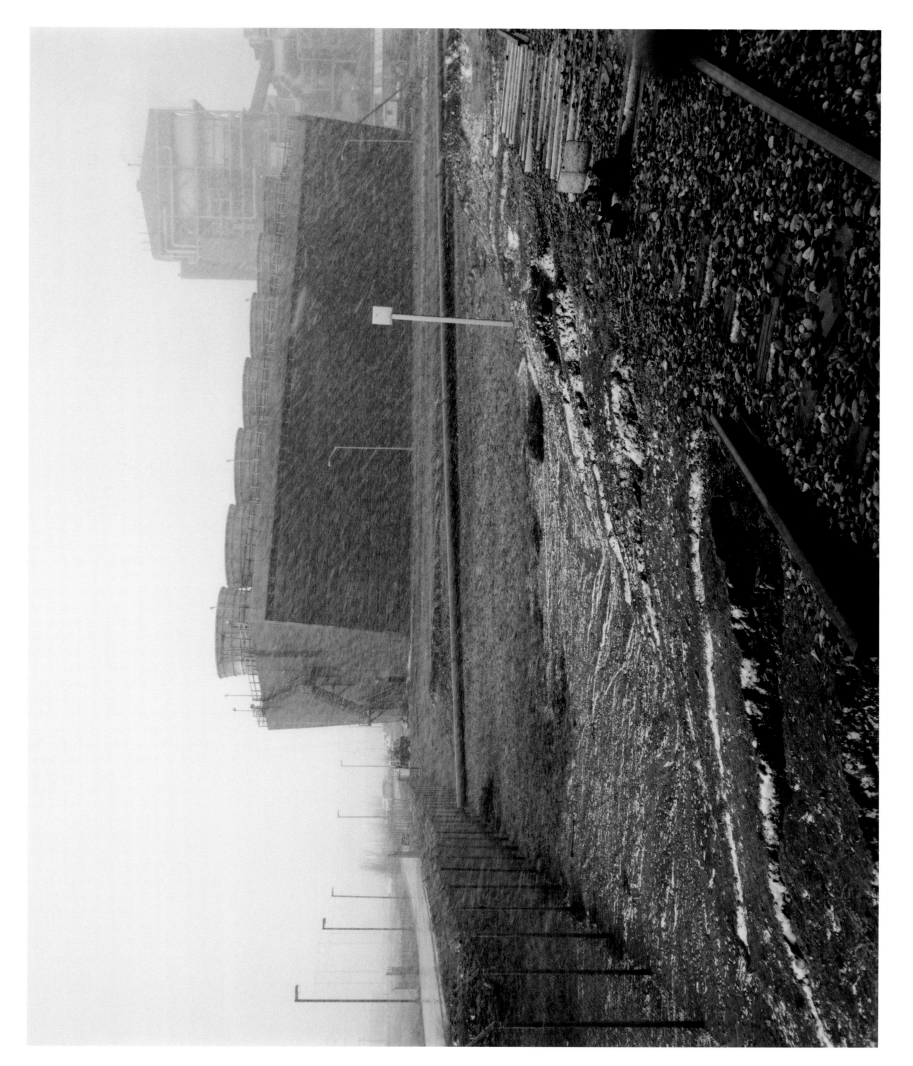

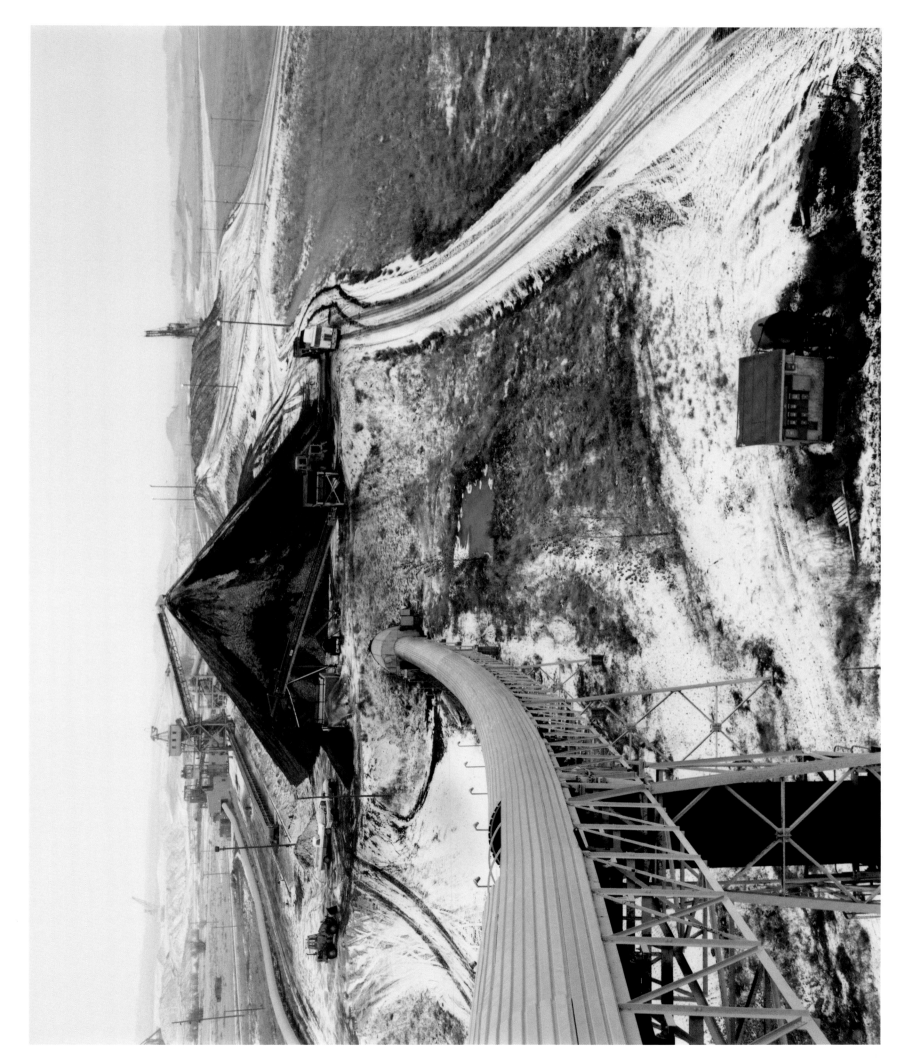

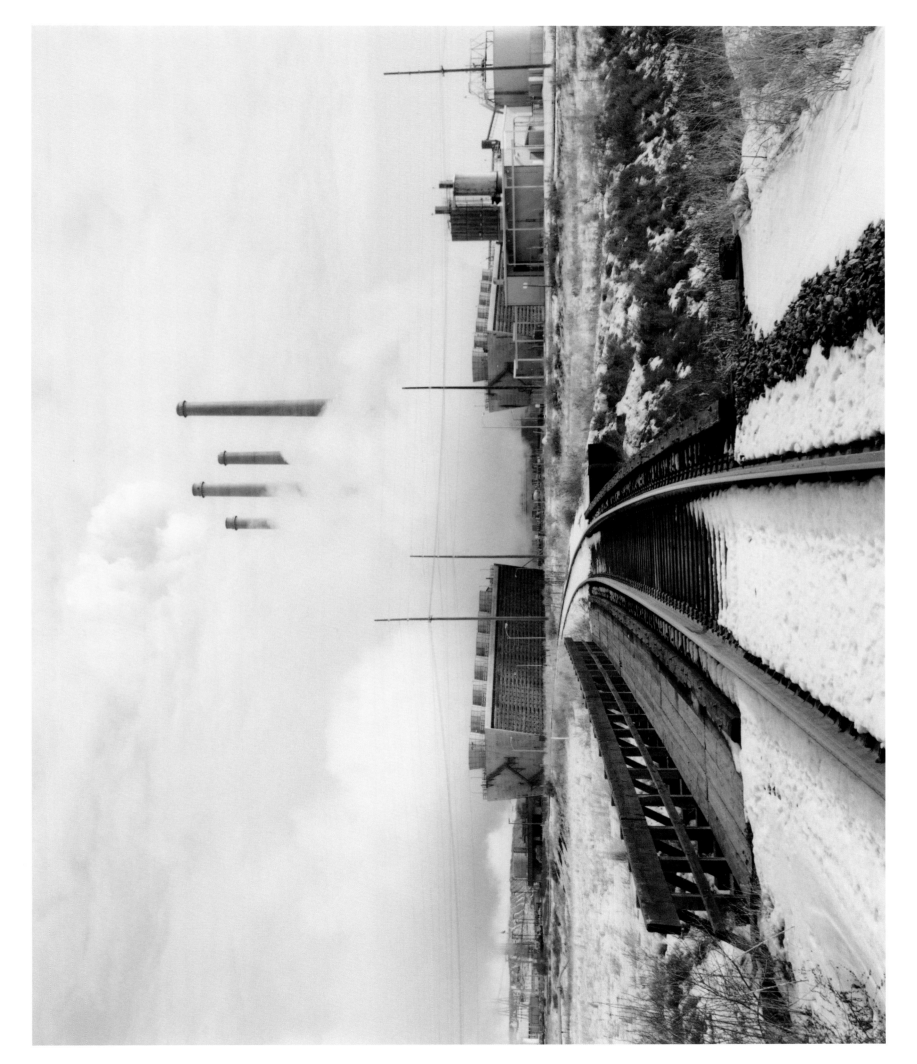

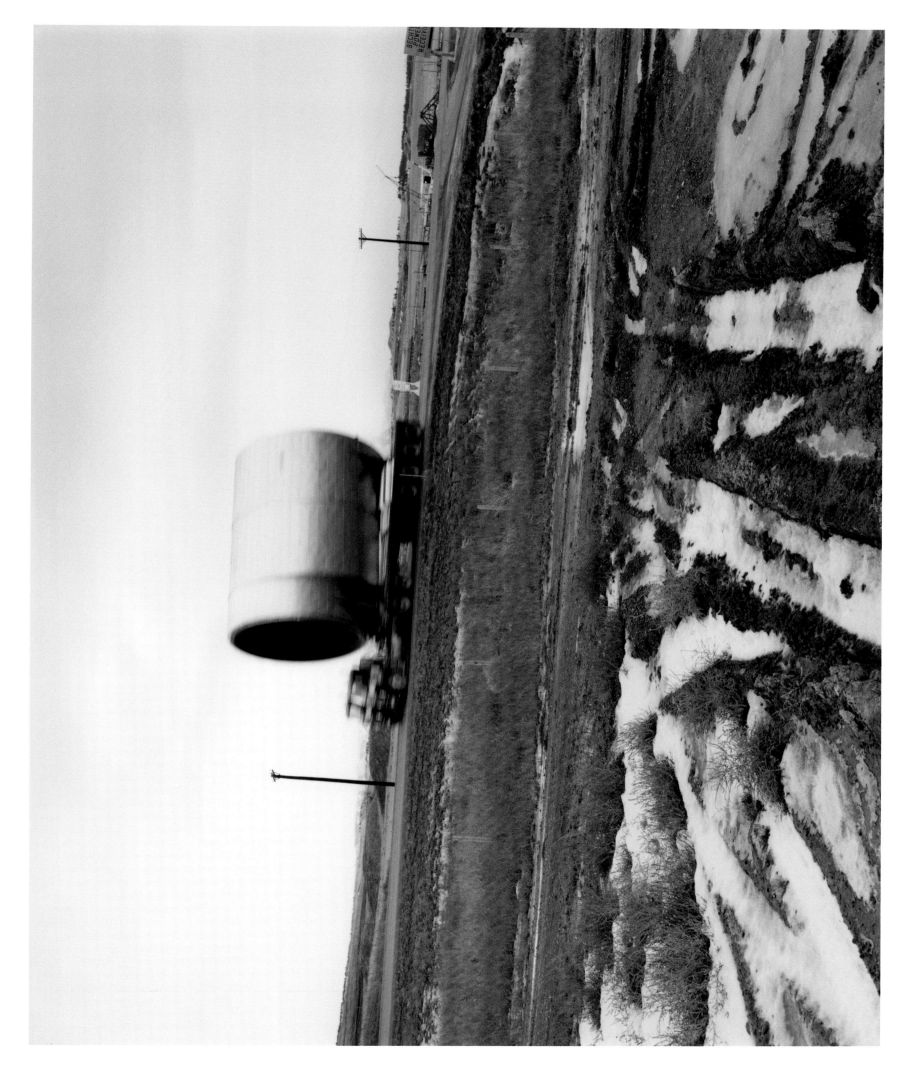

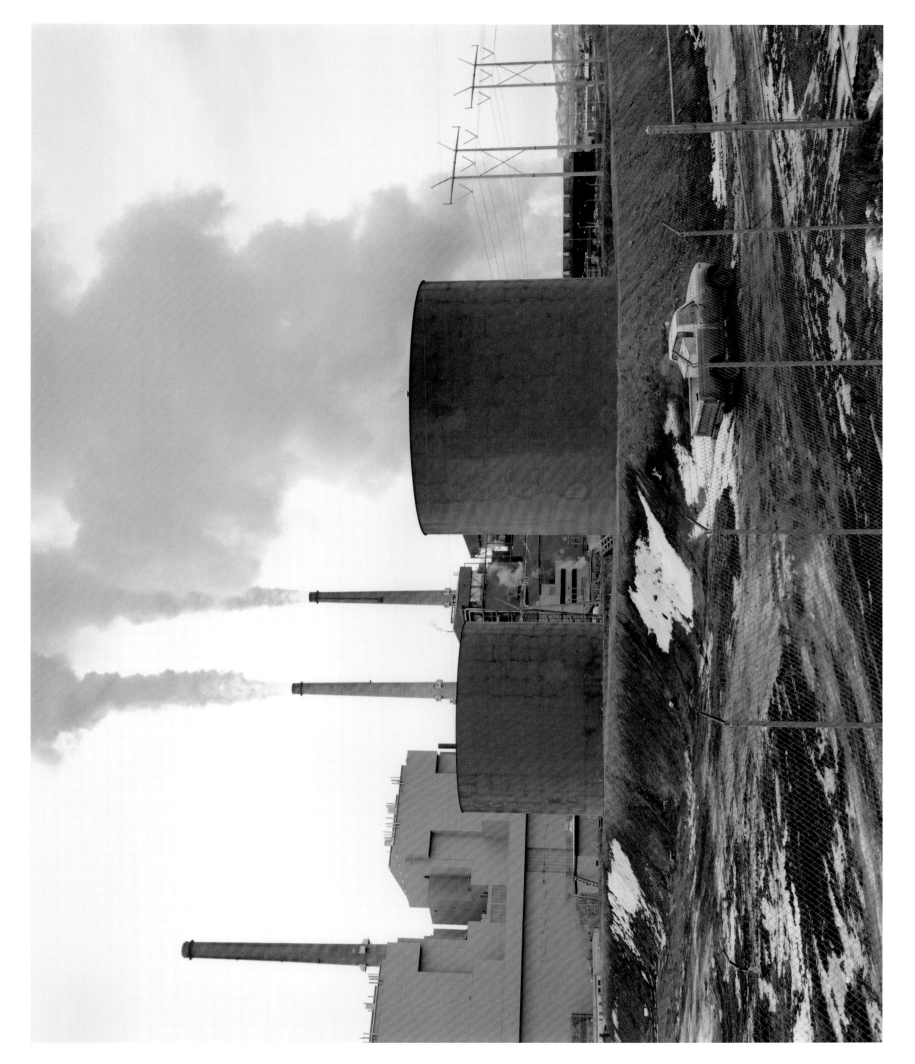

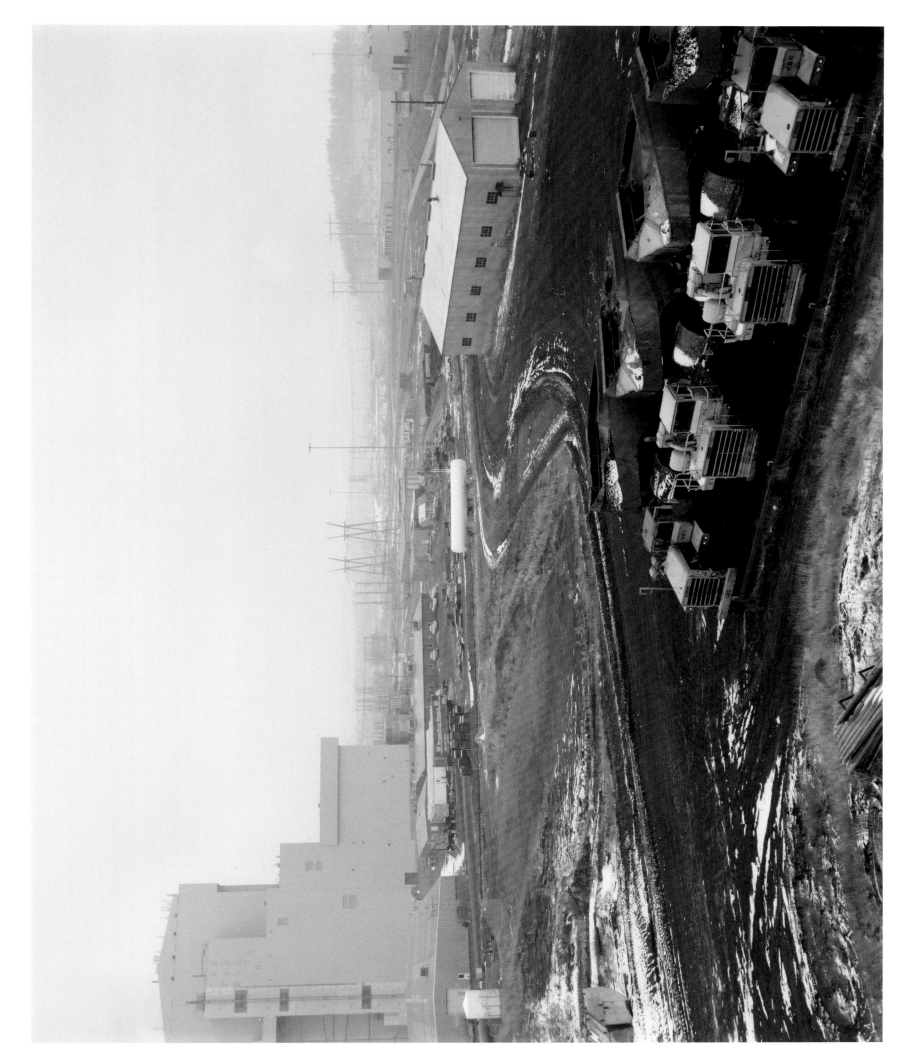

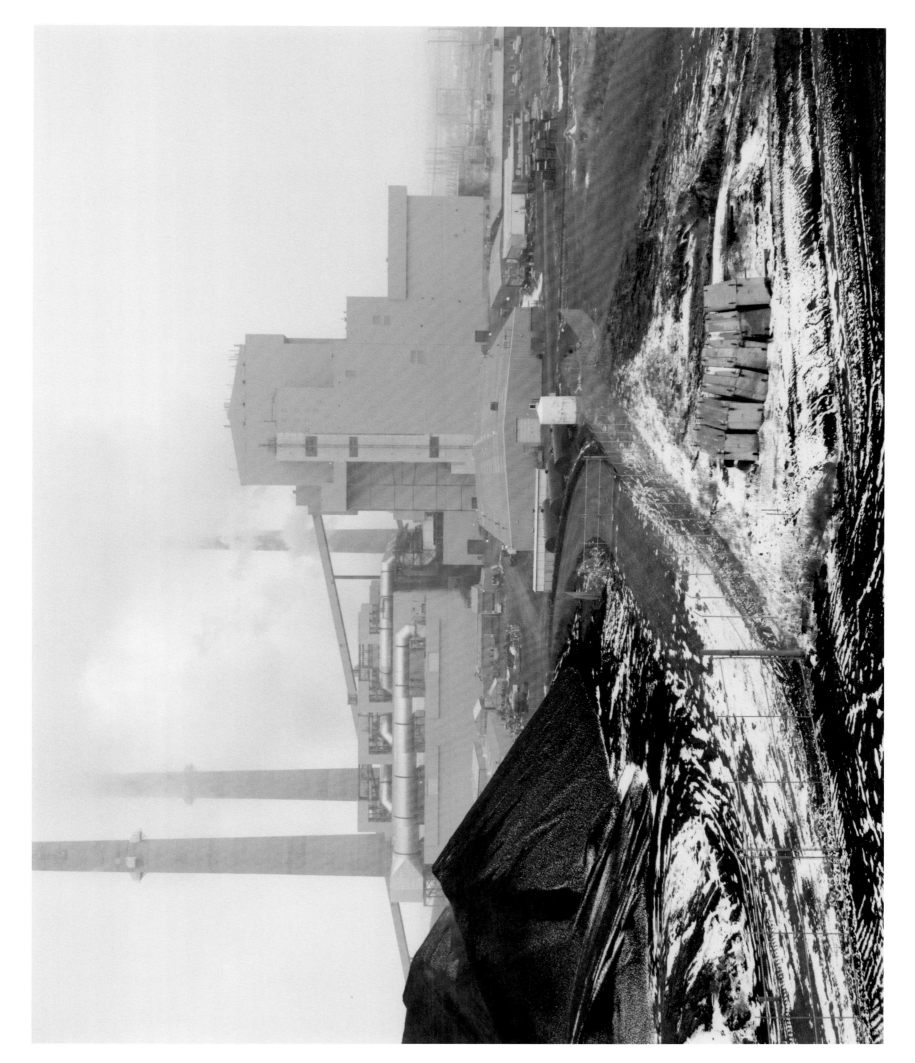

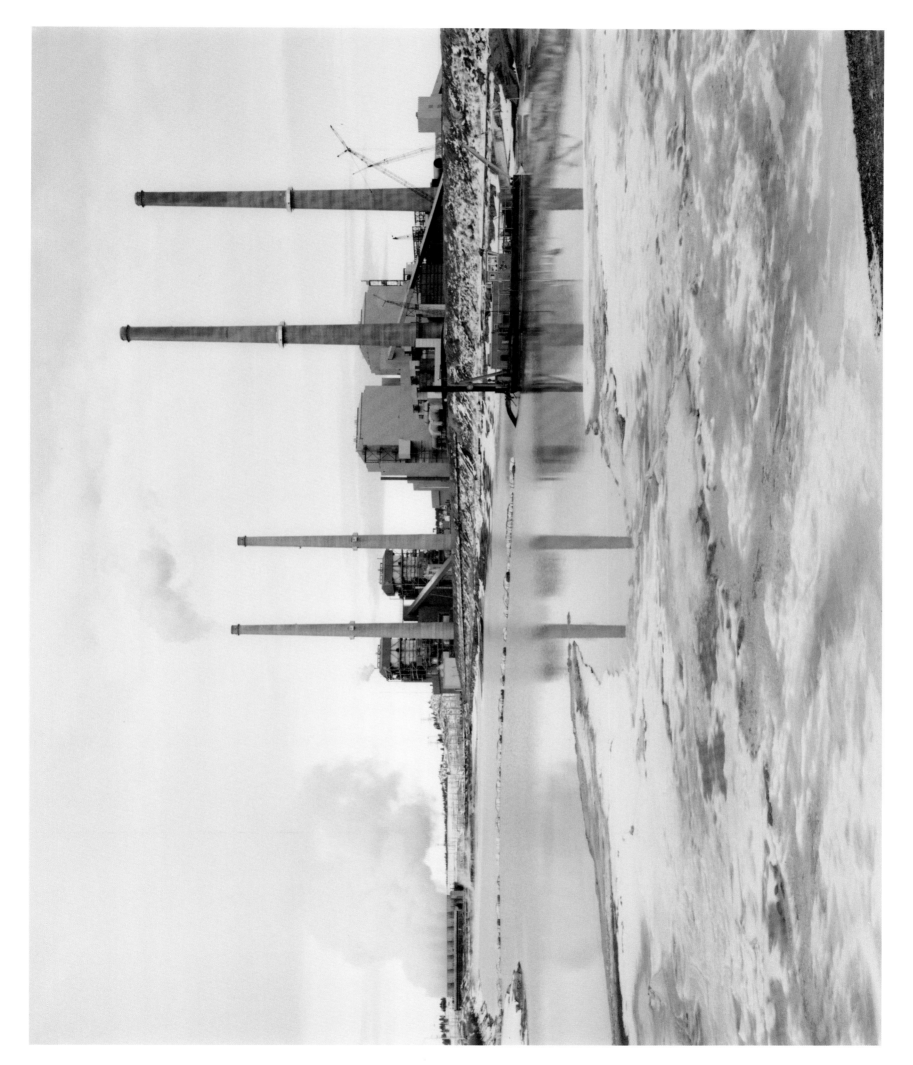

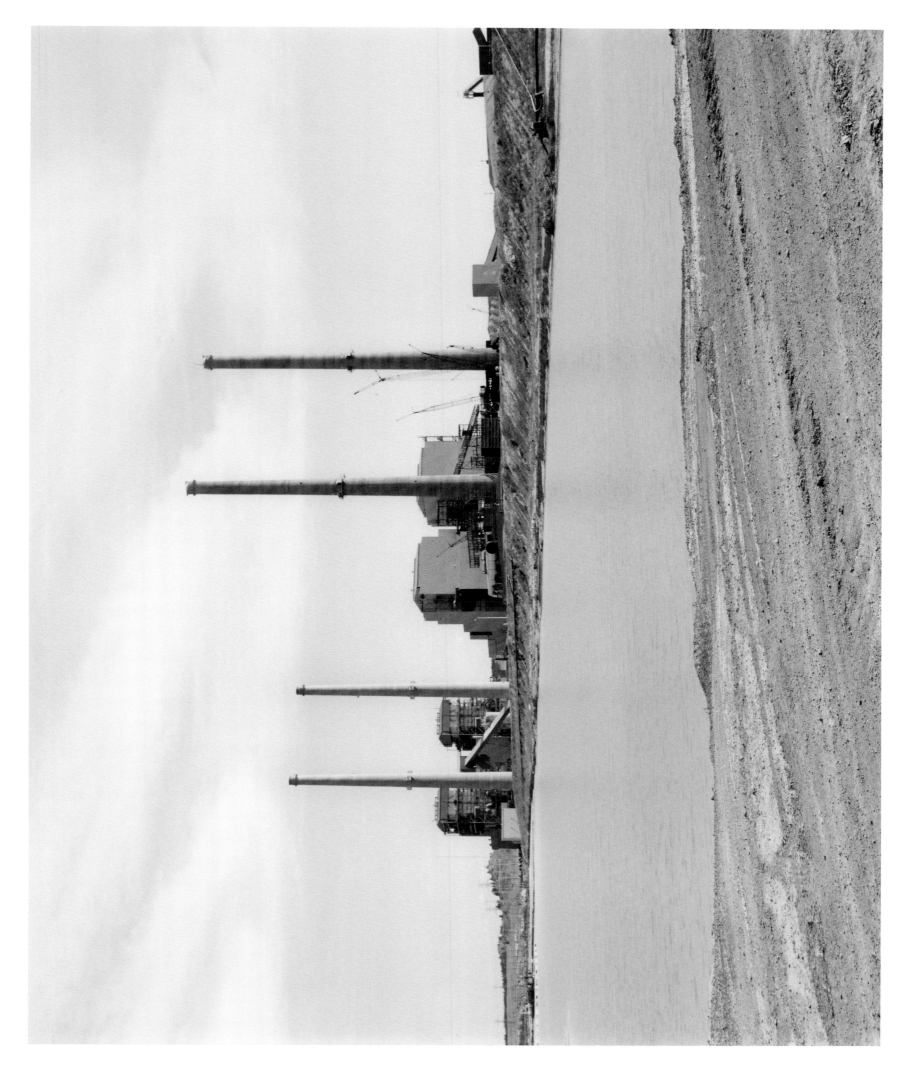

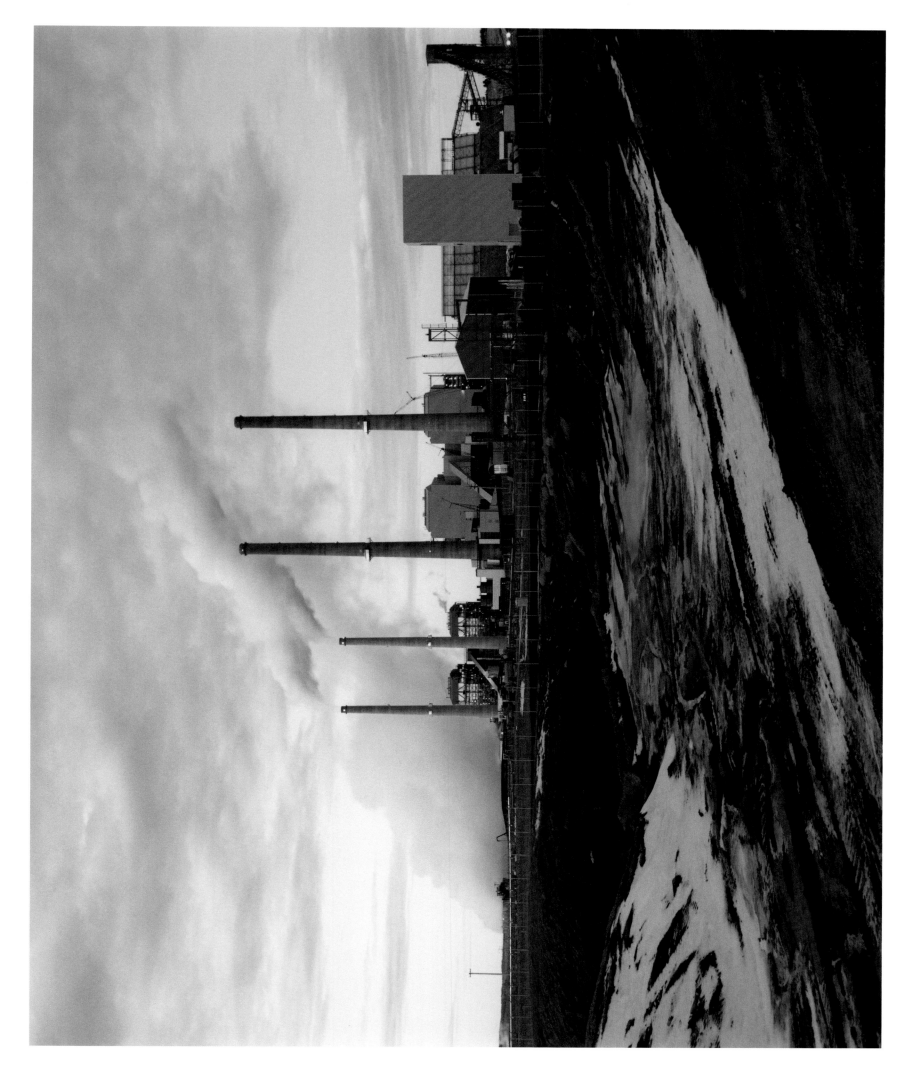

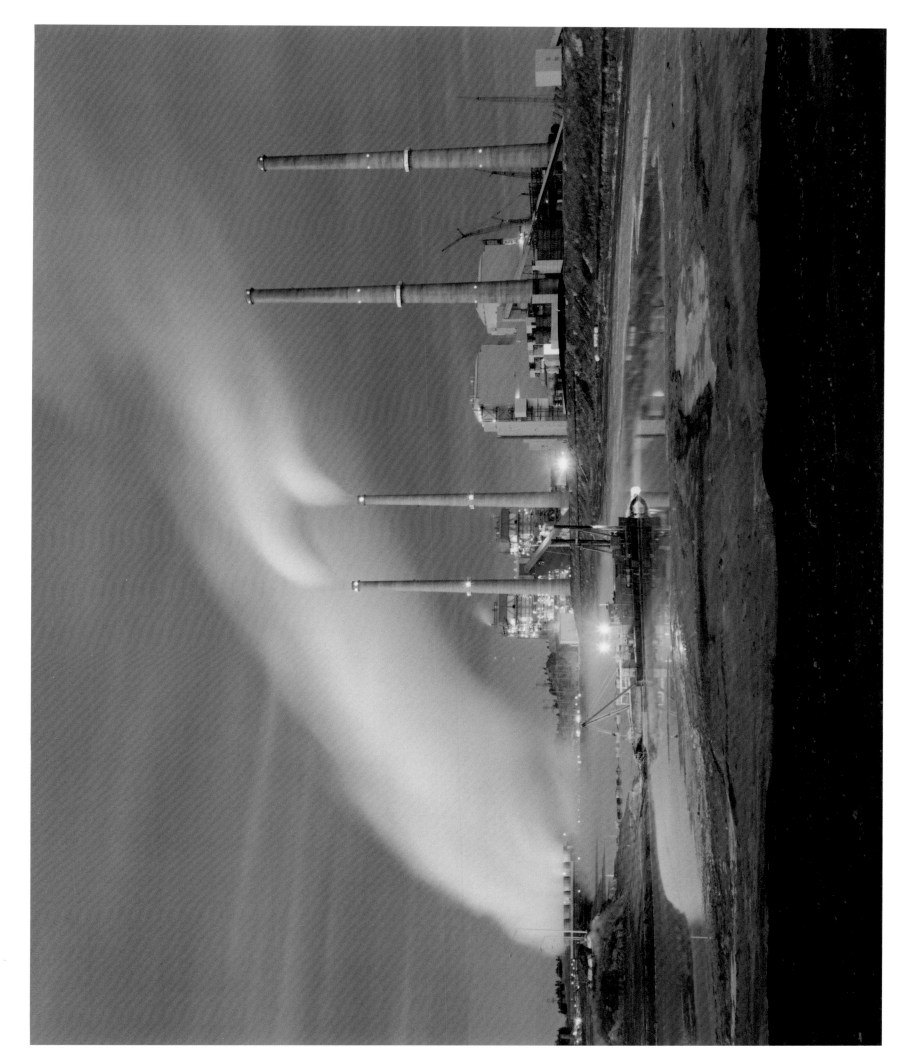

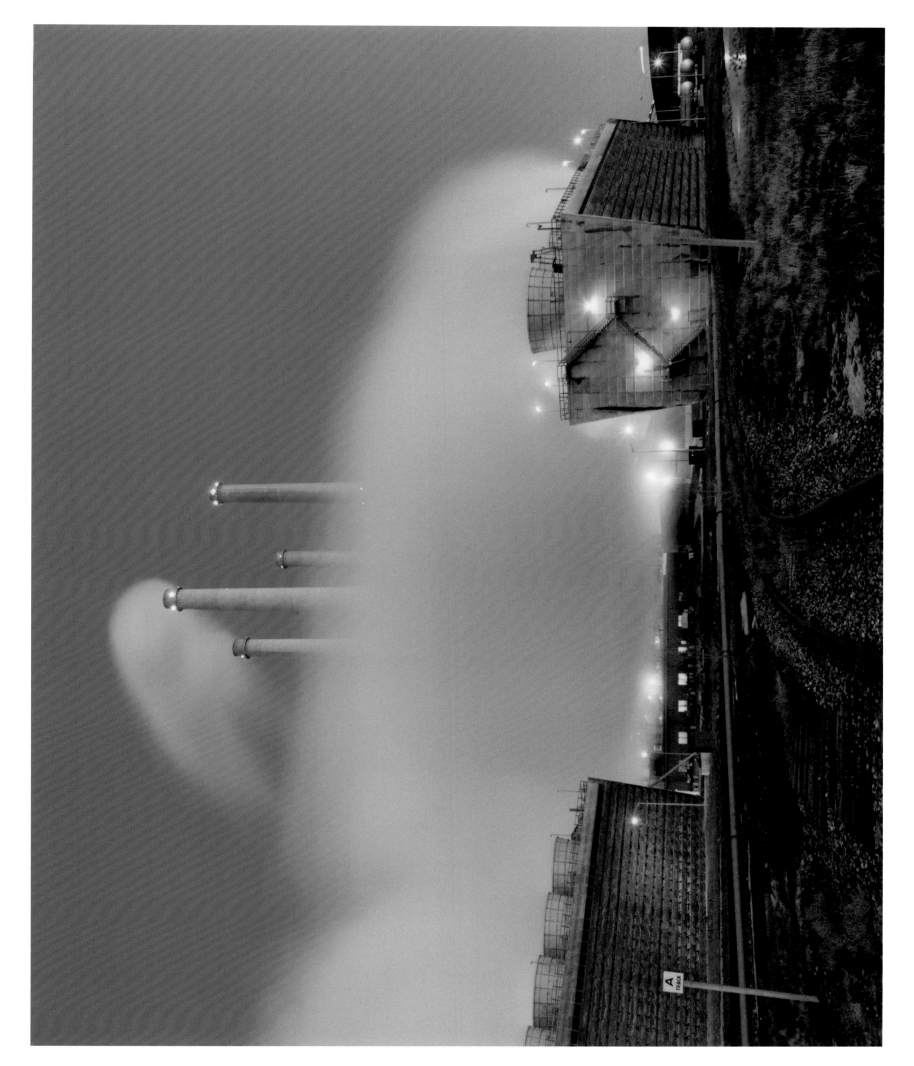

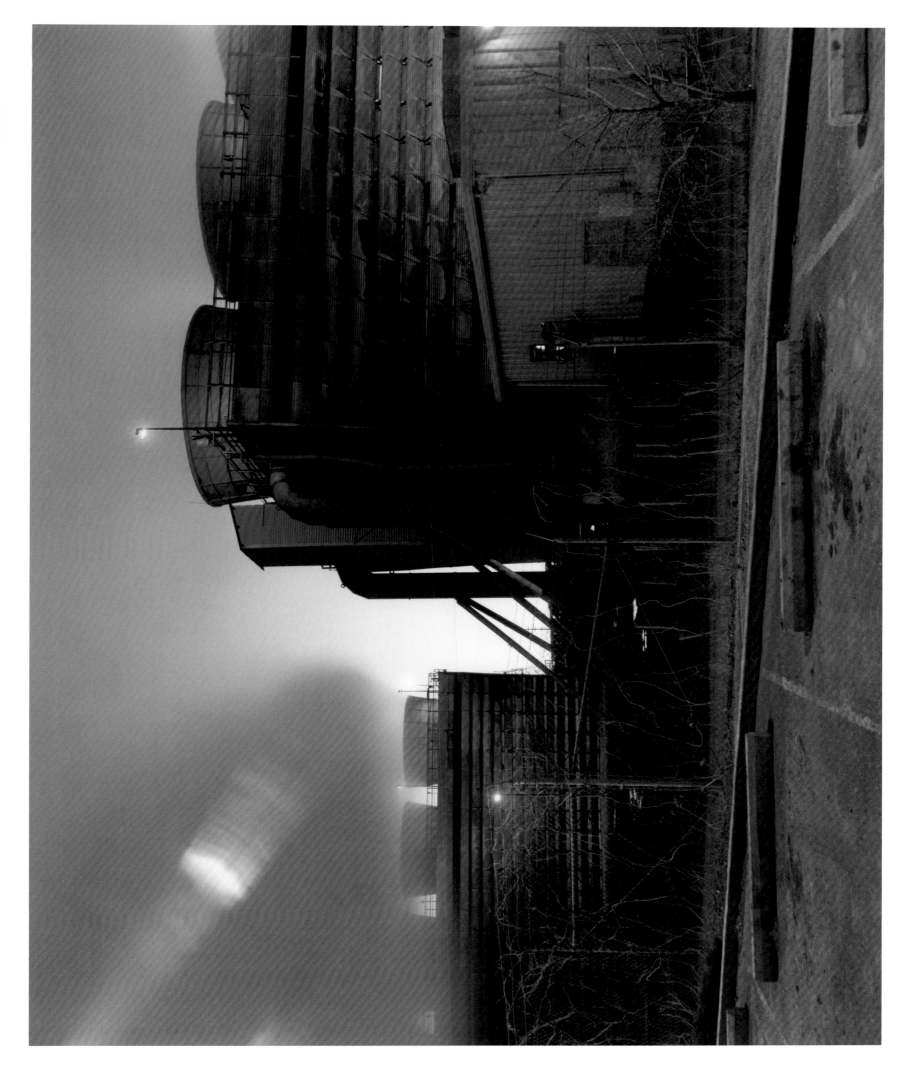

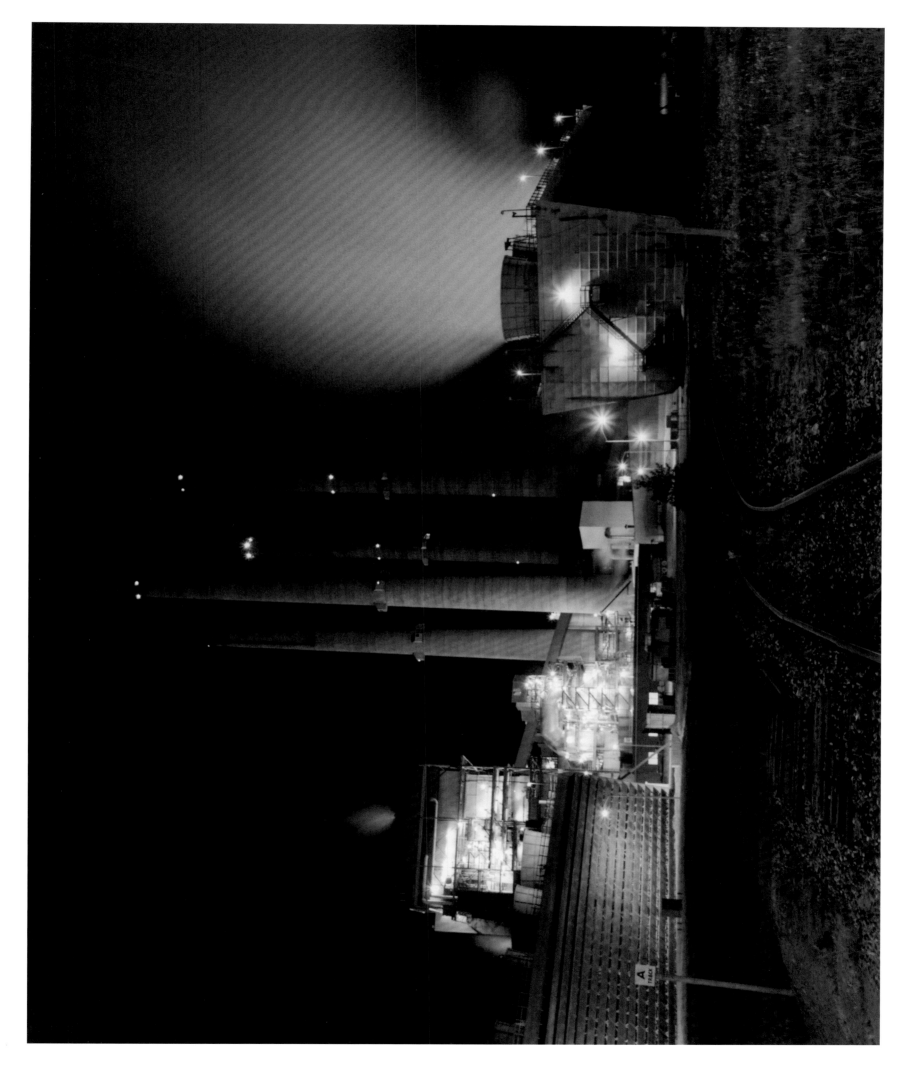

View from North Camper Village: power switching yard

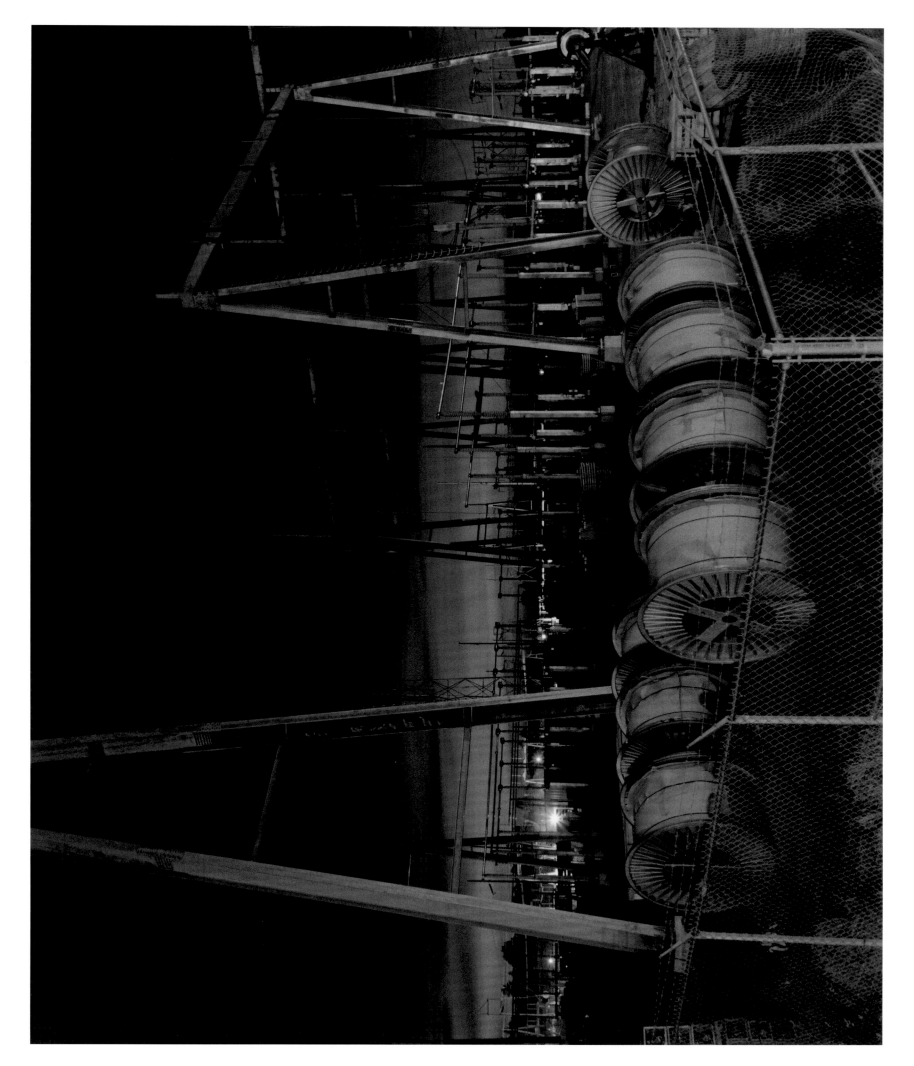

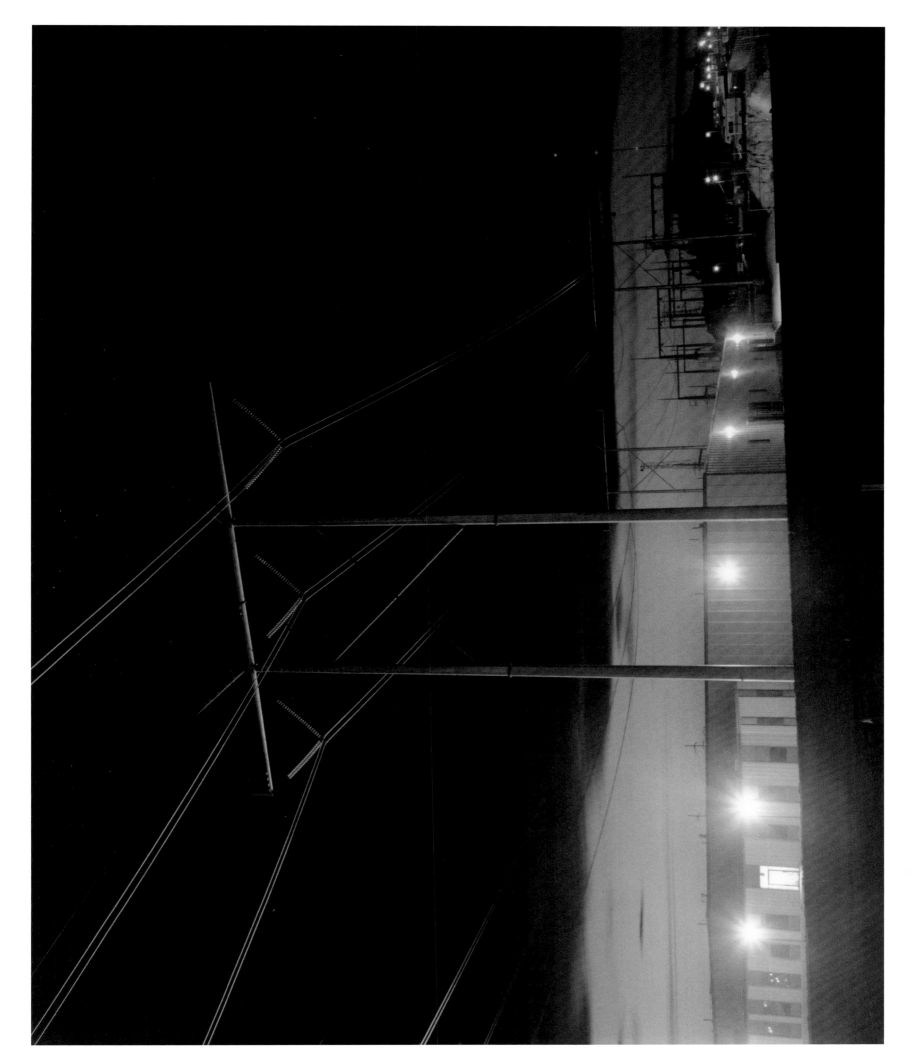

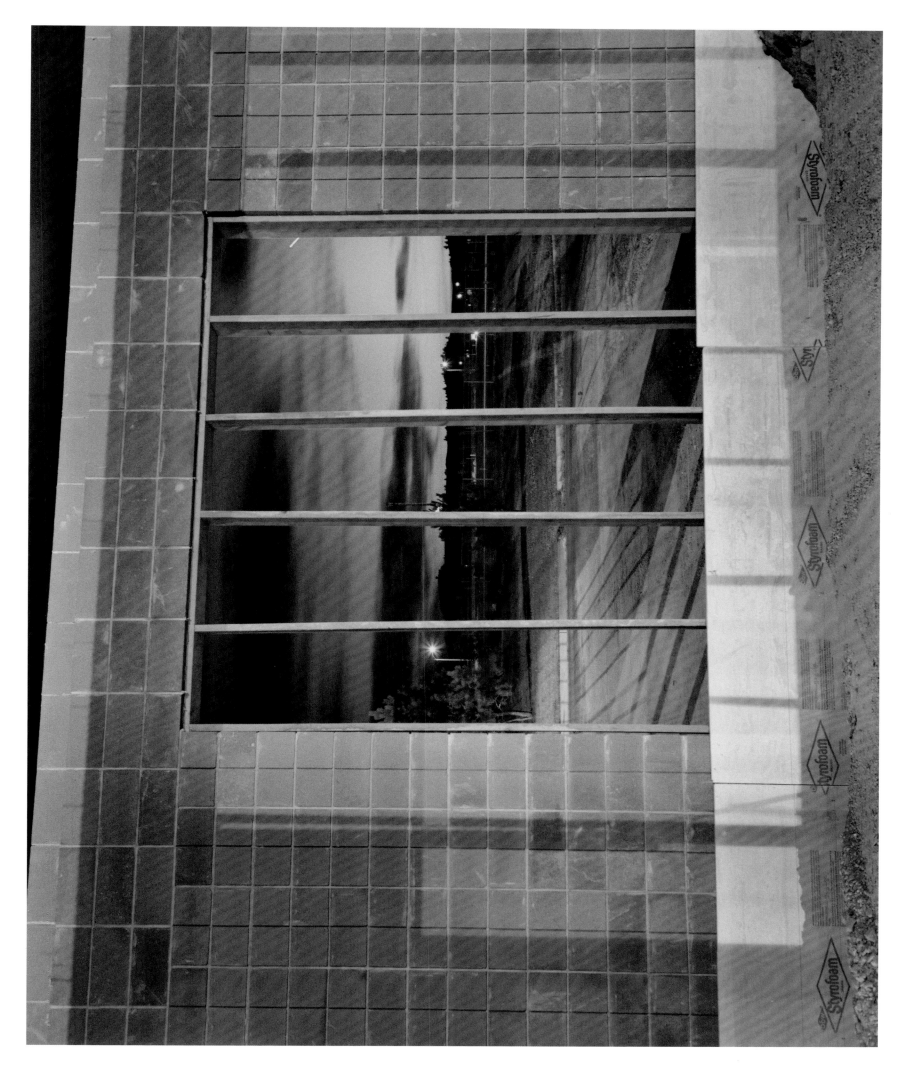

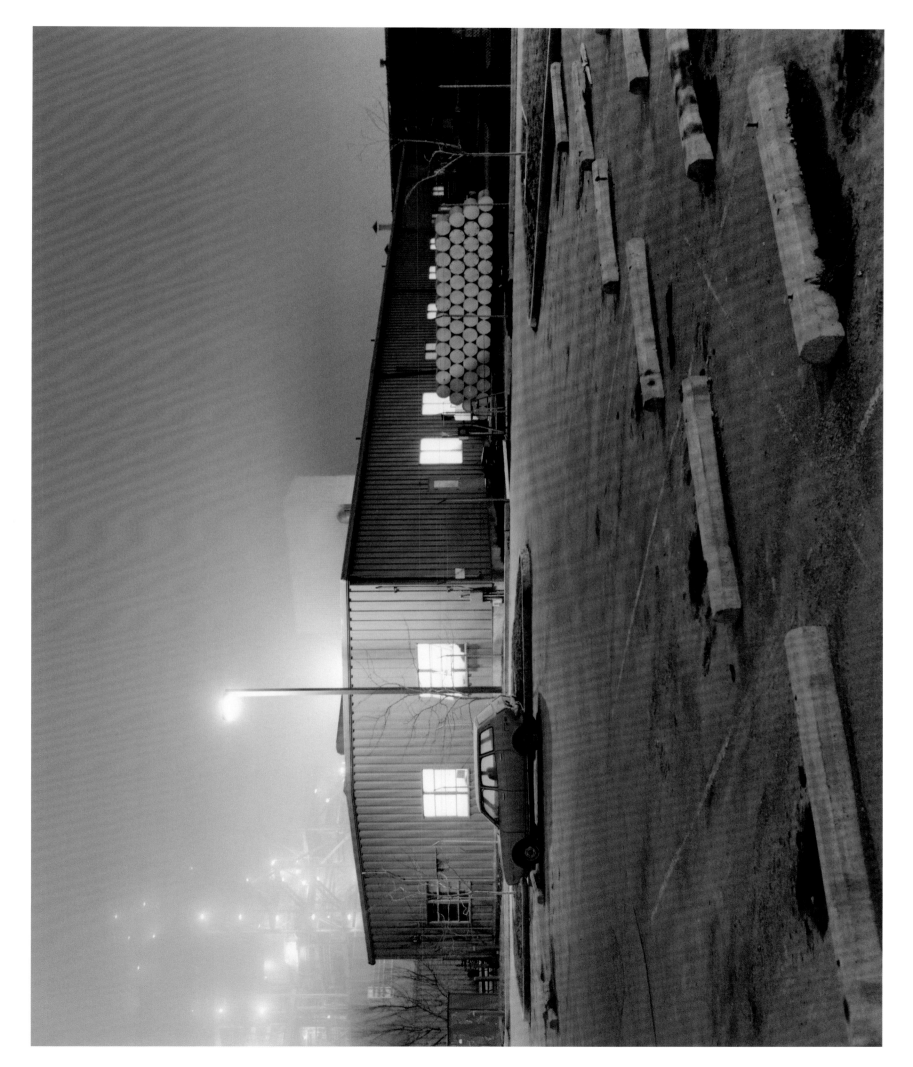

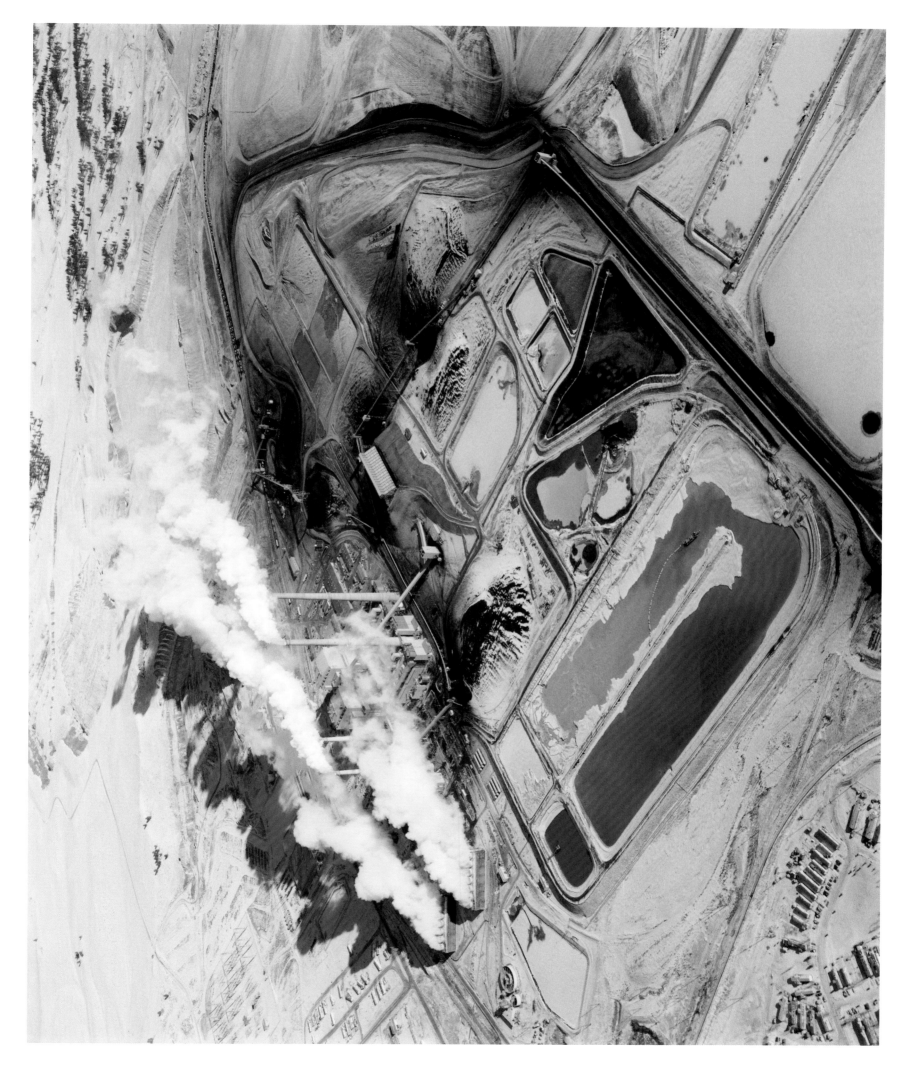

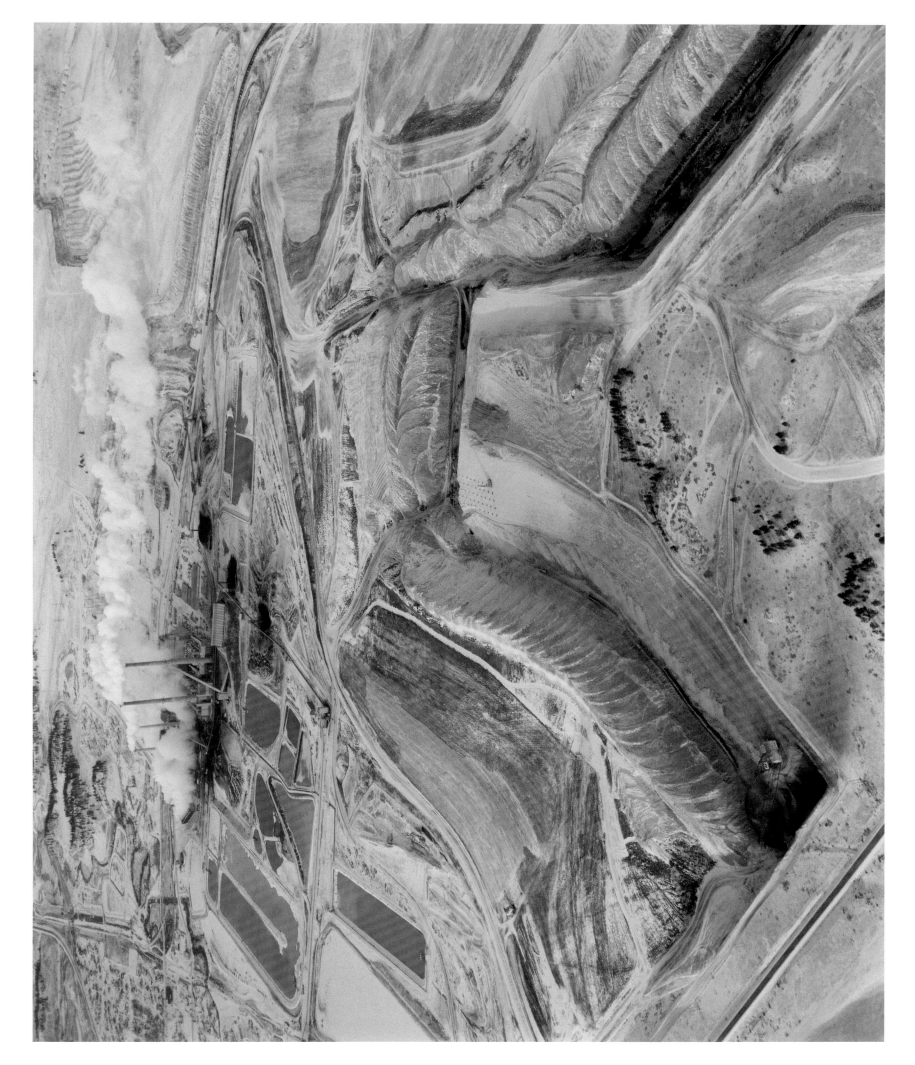

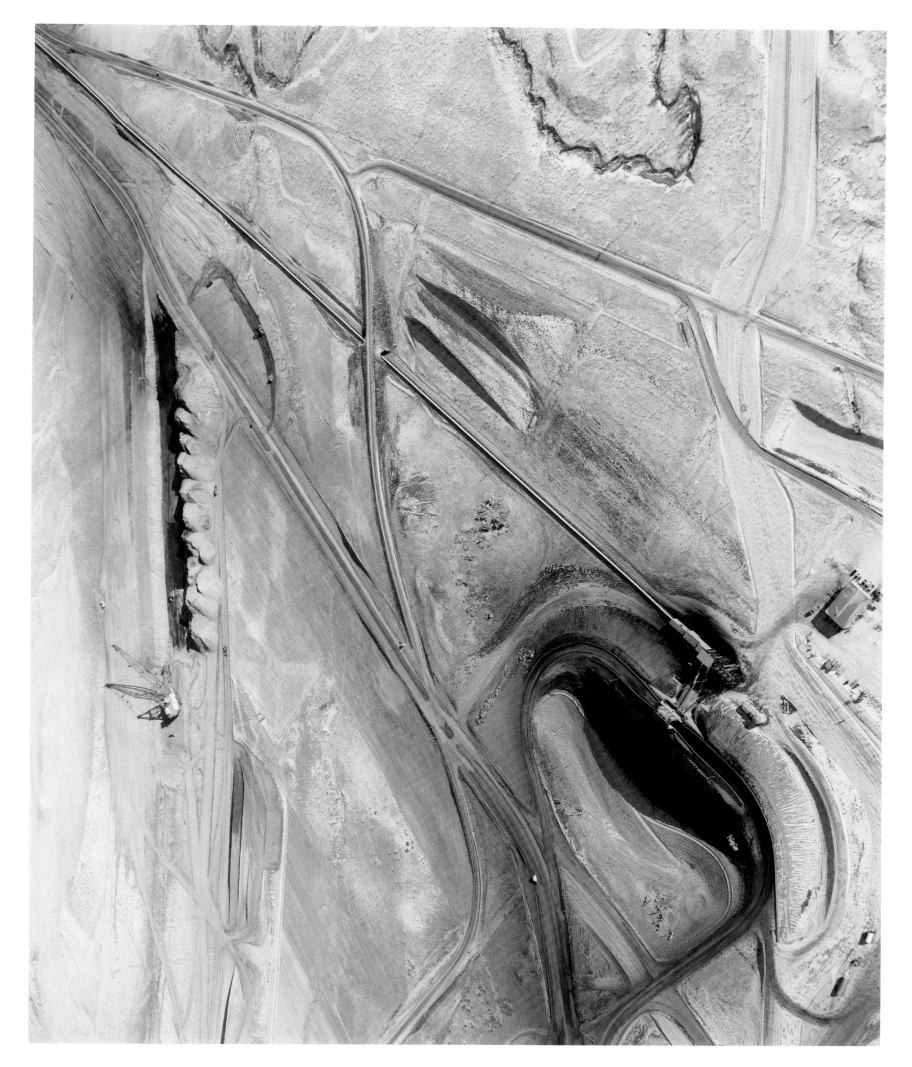

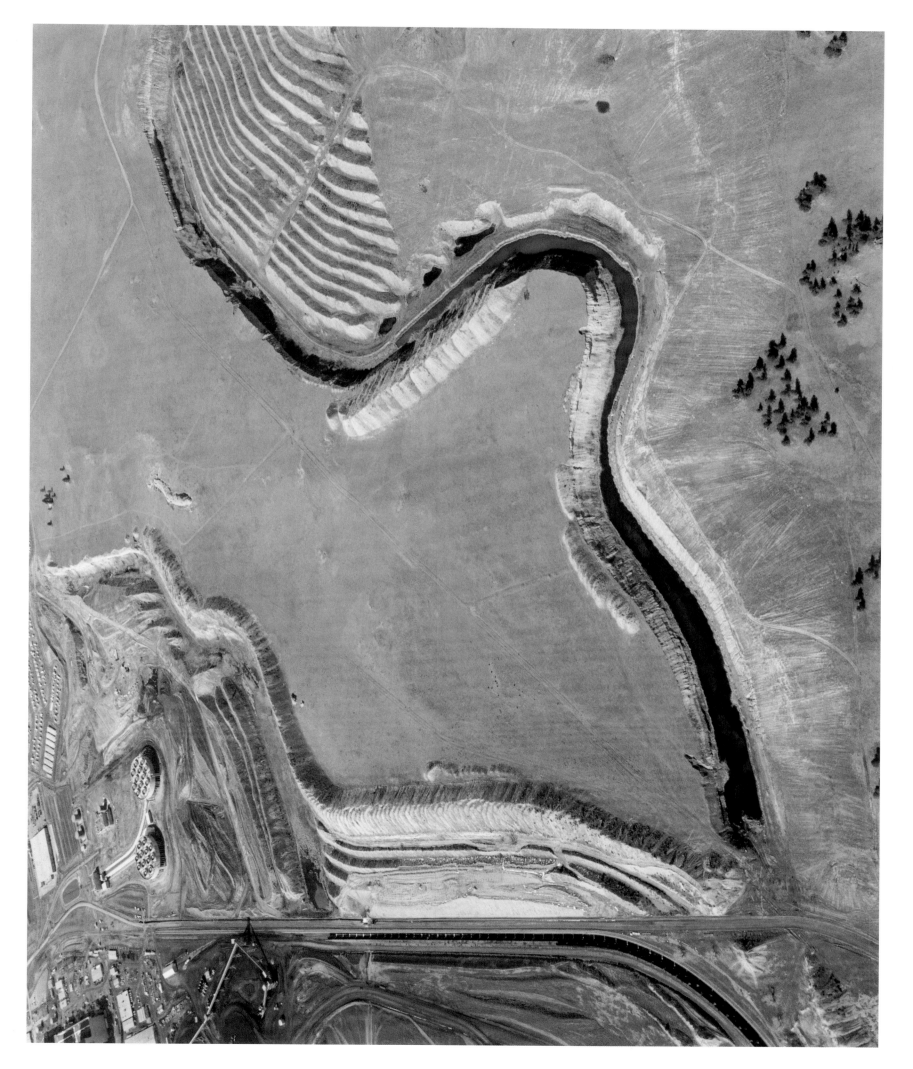

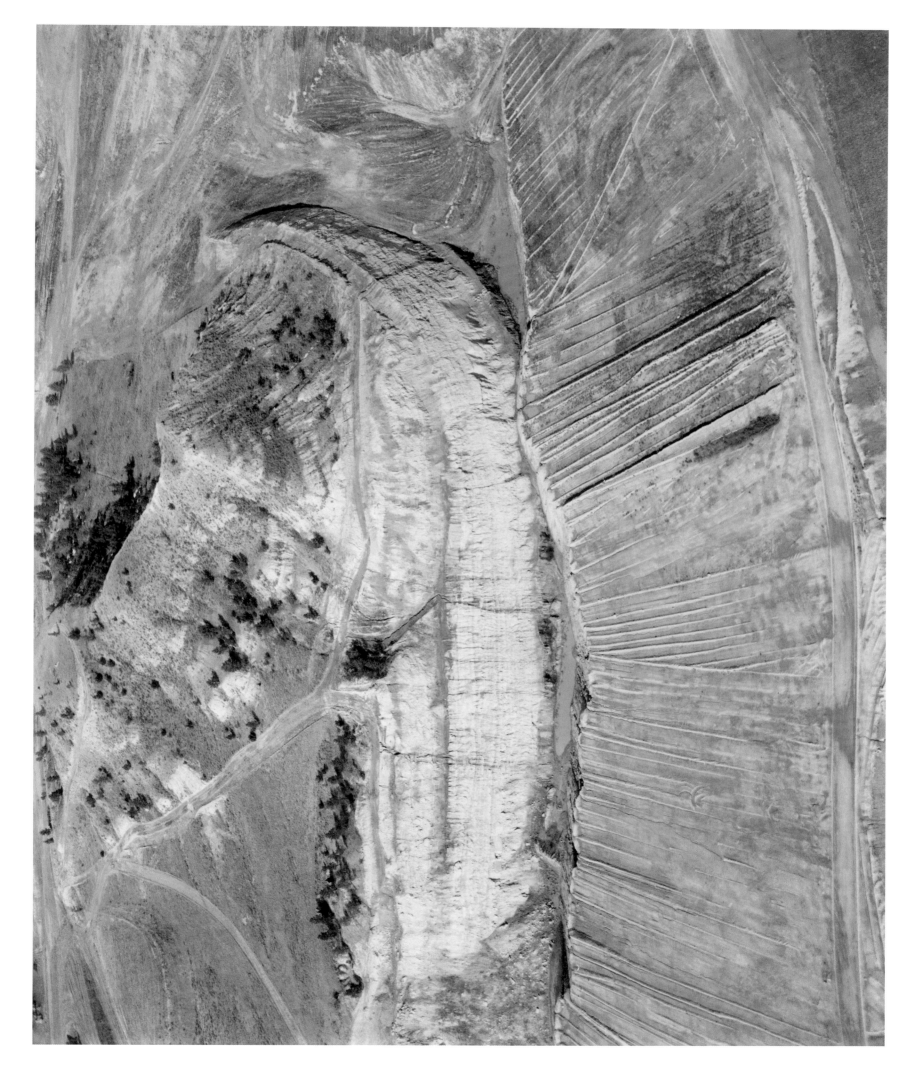

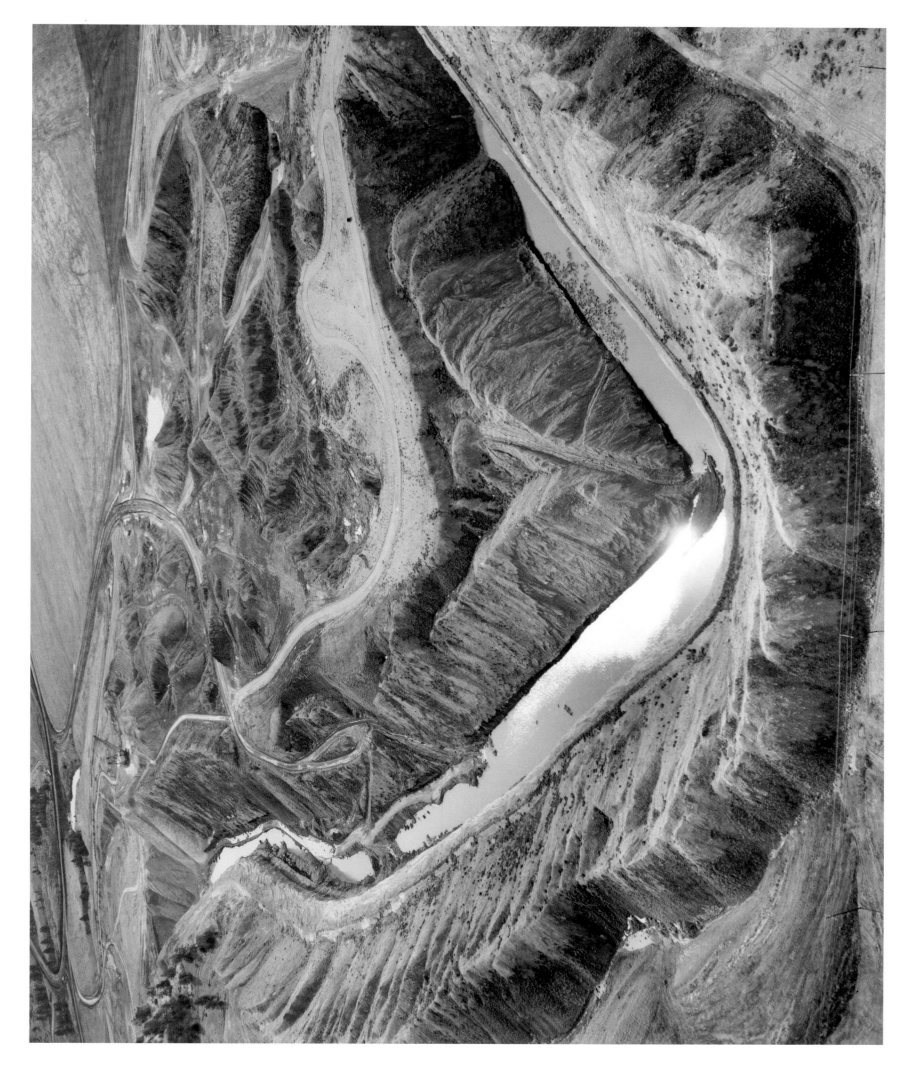

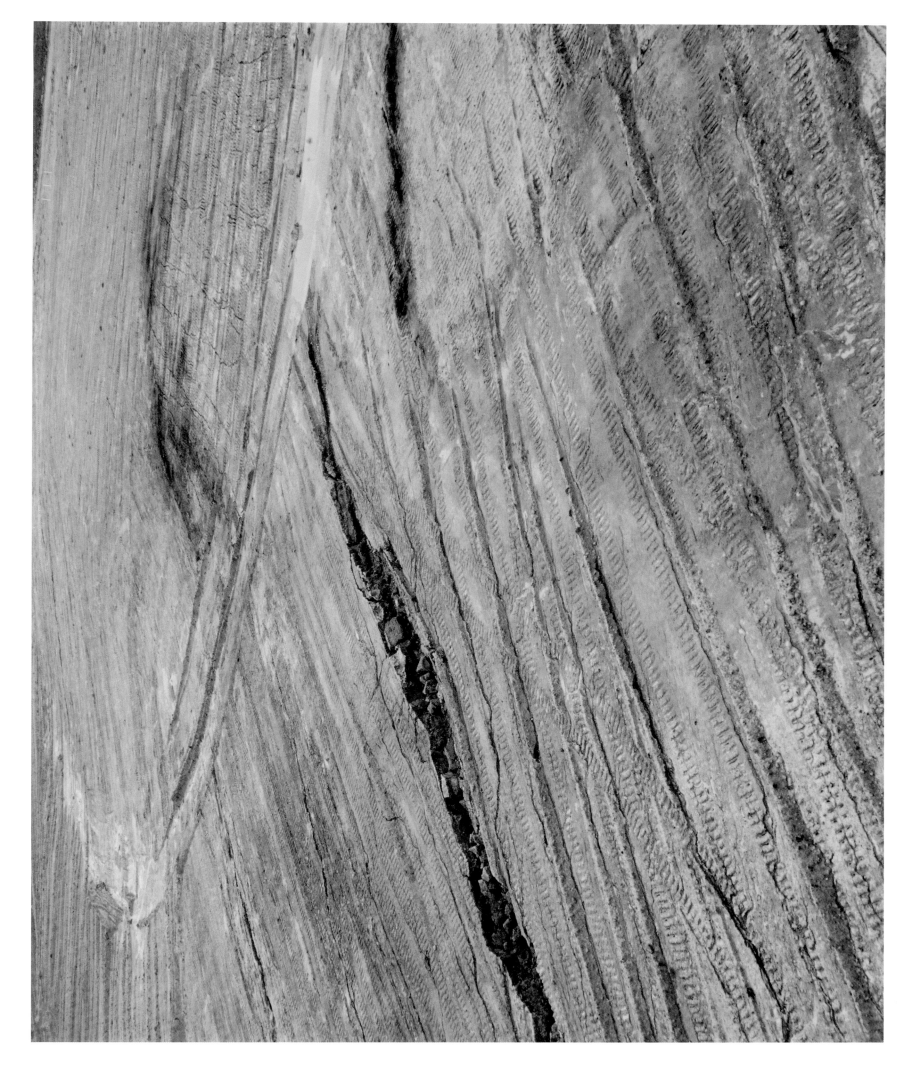

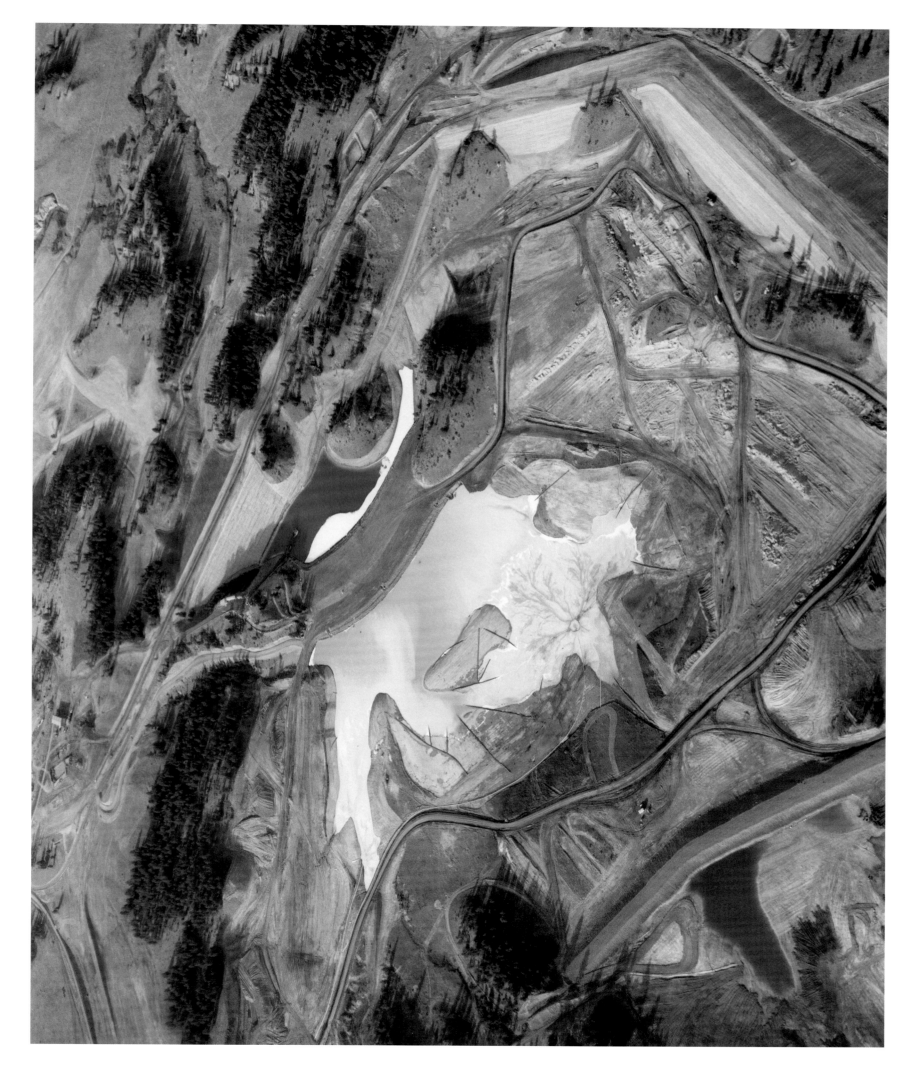

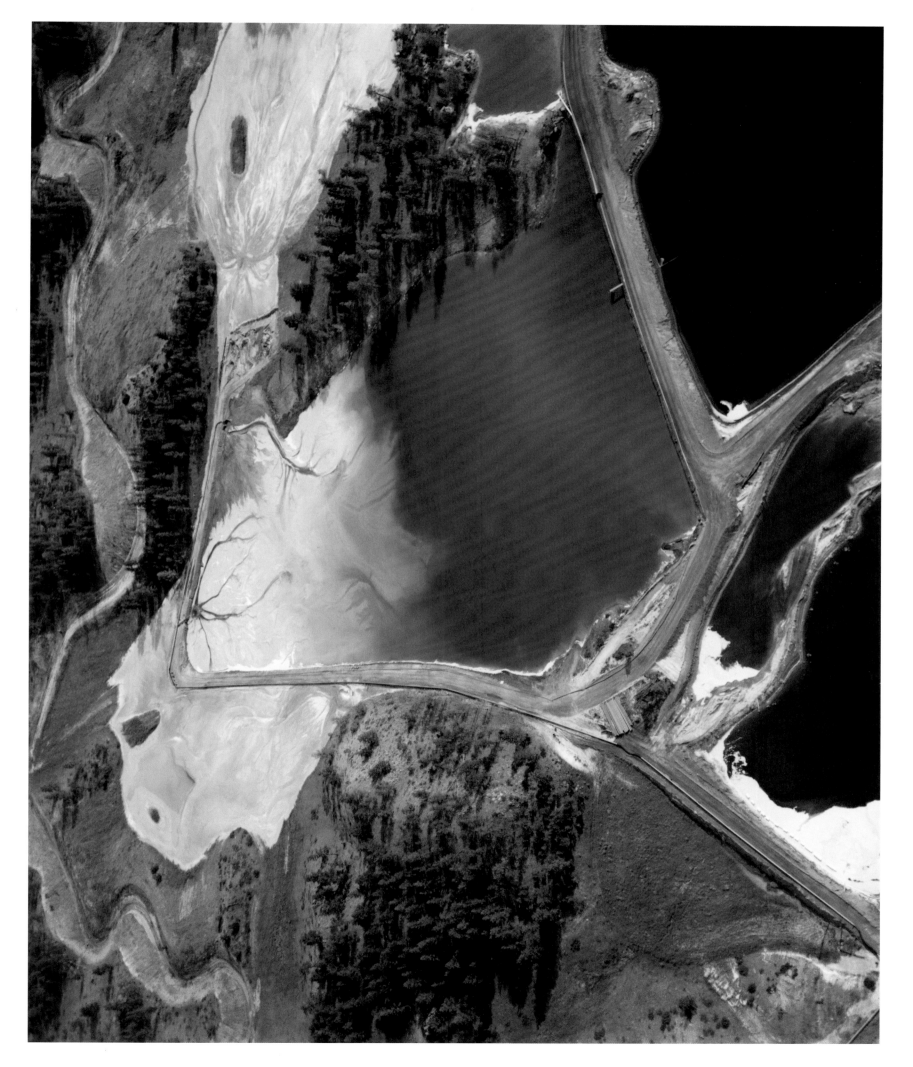

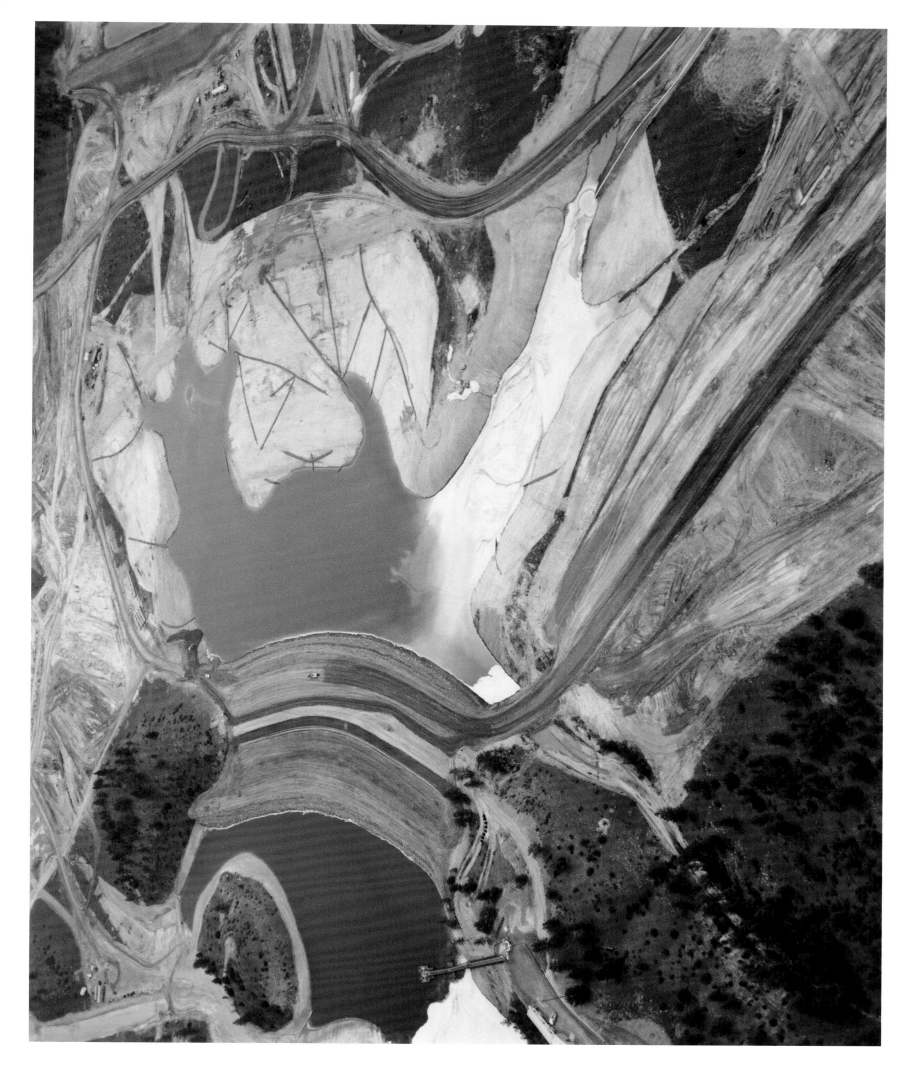

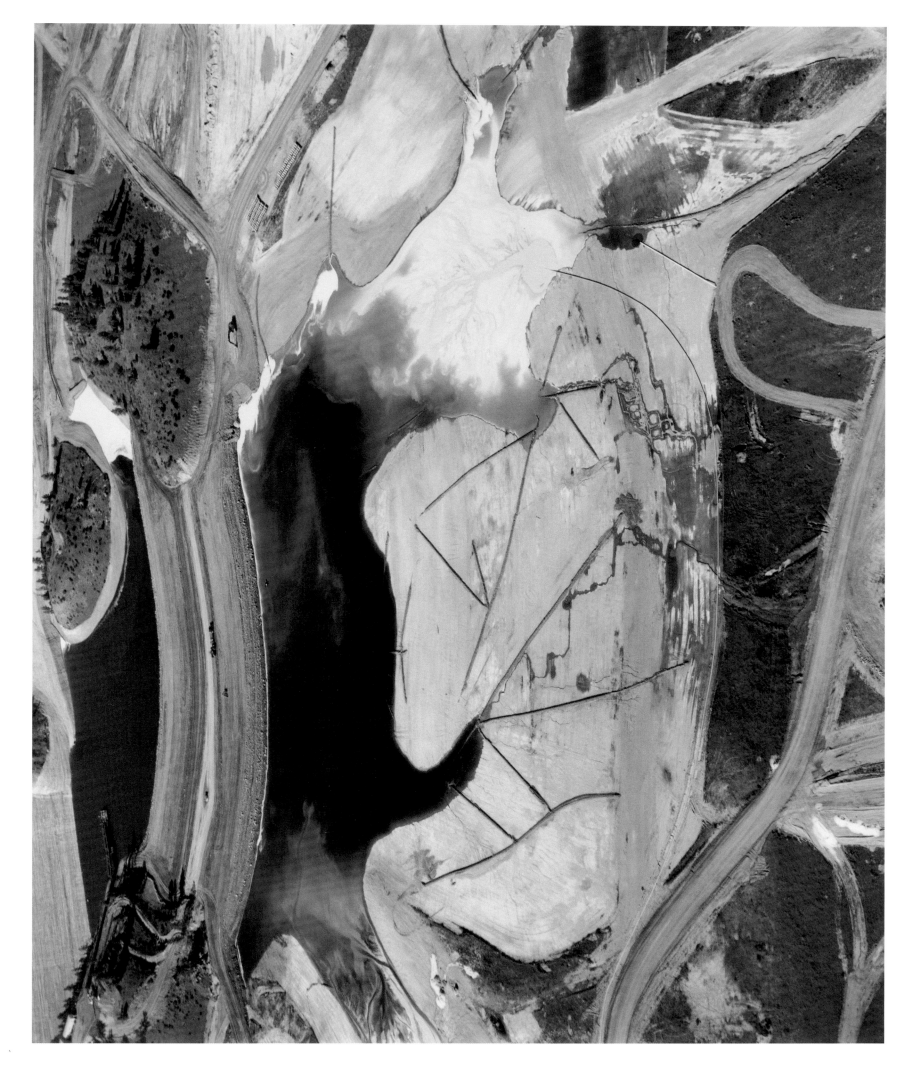

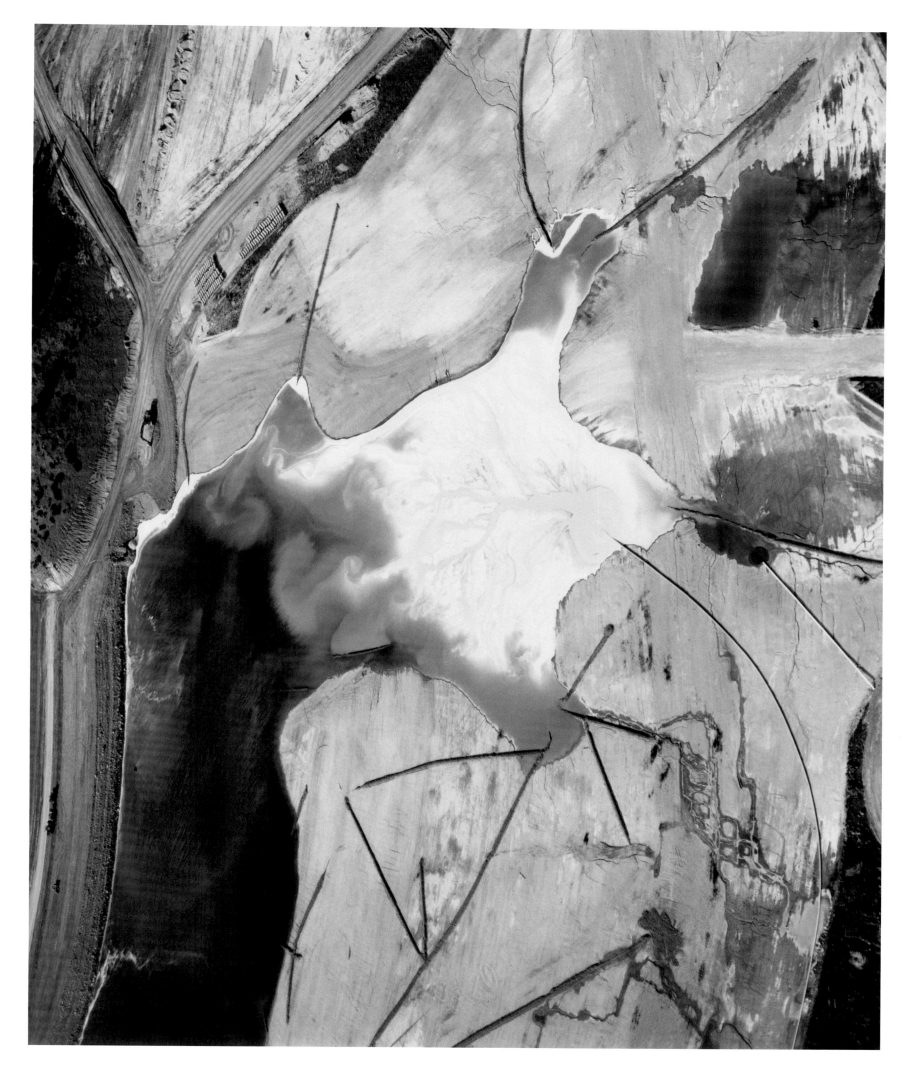

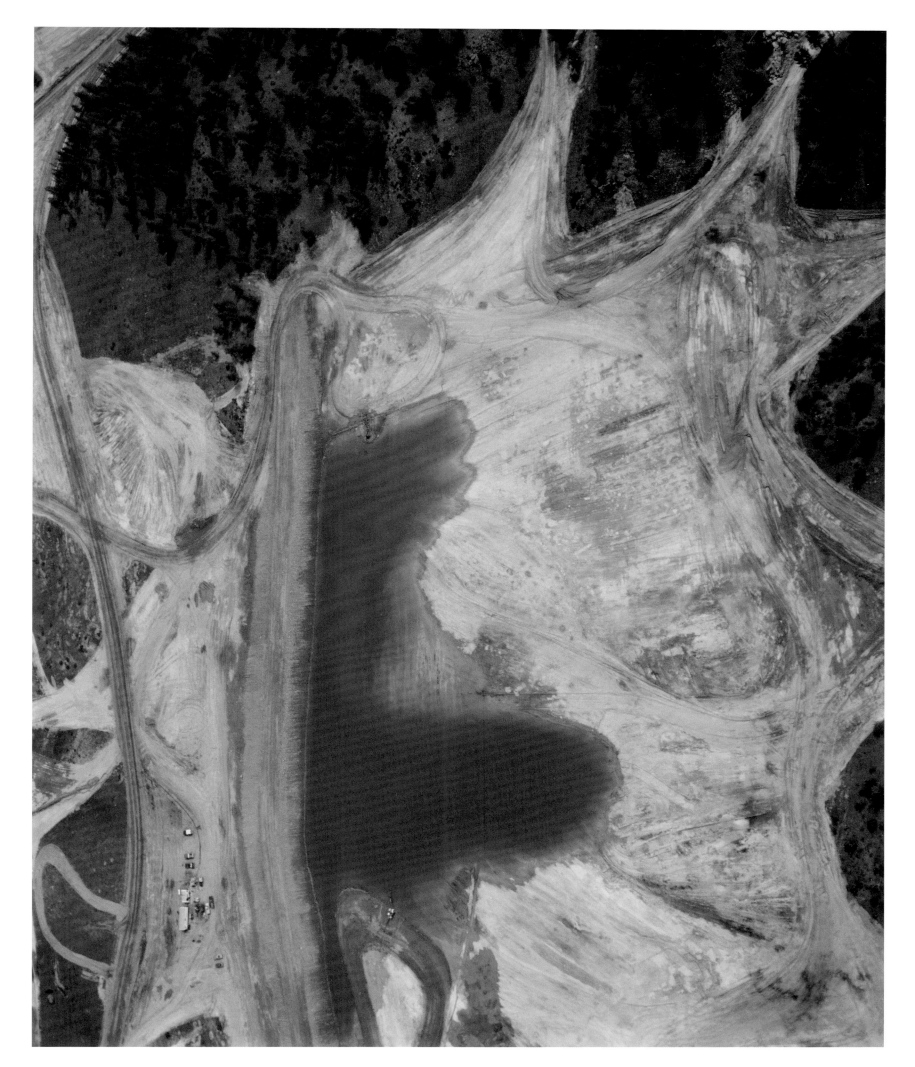

East of Billings

Rick Bass

These photographs were made by a native of Montana, a man familiar with the natural curves and flexures of the vast landscape down near the Wyoming and South Dakota borders. David Hanson grew up only a hundred miles from the town of Colstrip, and when he was young he hiked the rolling hills, sandstone buttes, coulees, and sagebrush country that had not yet been shoveled up and hauled away or burned in sulfurous plumes. Hanson left Montana to study at Stanford, but before that he spent a summer working the graveyard shift in a big oil refinery in Billings, cleaning the smokestacks. He stood on scaffolding inside the huge chimneys, jackhammering loose the black coke that had accumulated there, clogging the chimneys like arteries. It was hellish work.

There is a long American tradition of eliciting art from wounded landscapes—in literature, Edward Abbey's *The Monkey Wrench Gang* and *Desert Solitaire*, as well as John Graves's elegiac masterpiece, *Goodbye to a River*, come to mind. But when a literary artist addresses a collapsing society, system-wide calamities are usually masked by the veneer or façade of a still-functioning world. Life proceeds through buried tensions. In Colstrip, everything's been dug up. The scale of disorder at Colstrip is overwhelming. It's visible. The only thing missing is any significant roster of witnesses. The wide-open spaces shield the secrets from the rest of the world.

I've lived in Montana for over two decades, in the far northwestern corner, the wettest part, and I had heard about the "sacrifice zone" of the southeastern part of the state, and about how it has always been isolated and barren—as if that emptiness summoned a terrible loneliness that people could use to rationalize the degradation and destruction. David Hanson took the photographs of Colstrip and the coal mine and electrical power plant there in the early 1980s. I had seen his pictures long before I visited the place, but when I finally went to Colstrip, over twenty-five years later, I was shocked and surprised anyway. I had thought, for instance, that on the eastern side of the state, folks would be careful with something as rare and valuable as water. Not so. The power companies were still slinging it all over—piping it in from far away to aid in the processing of waste slurry, sucking it out of the ground, and then, once it was contaminated, letting it seep back down into the groundwater. An anthropologist in the future could infer that it was here on history's timeline that our species went mad.

There used to be plenty of water in the Powder River Basin, the semi-arid region that stretches south of Colstrip for about two hundred miles, into Wyoming. The Powder River Basin is the single largest source of coal in the United States. It was lush, hot, humid swampland in the Paleocene era, sixty-five million years ago. Then the swamps began to rot, which is what made the coal. The ancient swamps now lie stacked in brittle strata, sometimes only forty or fifty feet below the surface.

As the swamps rotted, their vegetation sank lower and lower, compressing to a nearly irreducible density, down into a lightless, airless crypt. The Paleocene vegetation had been fed by the fire of photosynthetic clamor. It filtered and absorbed carbon dioxide in the growing process—sequestering huge amounts of carbon—but then all that vegetation had to lie down and die for a while. Now its energy is being released again, and with the last giving-up of the energy, so too is all that stored carbon—millions of years' worth—being released, in giant, heated, ceaseless exhalations.

· · ·

It's nearly a seven-hundred-mile drive from my home, which is in a rain forest not far from the Canadian border, to Colstrip. I made the trip in the fall, and by dusk was some sixty miles east of Billings, where you turn off I-90 onto the last stretch of state road to the town and the plant. The land around there is gentle hills, neither too flat nor too steep, covered with prairie grass. Horses, their manes and tails blowing like the grass itself, stood on top of the hills looking down, while herds of Black Angus grazed in umber fields. Custer made his last stand right here, in the summer of 1876, and I stopped to look out at the Little Bighorn Battlefield National Monument. The gates were closed. I thought about sneaking in, but I didn't want to be disrespectful.

The Park Service, in conjunction with the Cheyenne and Lakota nations, has done an impressive job of interpreting the Little Bighorn battle. Austere white marble headstones are clustered in places where the bones of soldiers were found. More recently, markers have been added to honor the native warriors who fell. Prior to the battle, settlers had been swarming into the Black Hills, in South Dakota and Wyoming, although only a few years earlier a treaty had granted the land to the tribes in perpetuity. As a Park Service website describes it, in 1874 the United States had "sent a geological

team, under Custer, to examine the minerals in the area. Gold was among the minerals found, and not Caesar himself could have stopped the barbarian hordes of miners flowing into the reservation." The Black Hills were declared outside the control of the tribes, and the Lakota and the Cheyenne who had chosen not to live on any reservation at all were deemed hostile. The confrontation in the valley of the Little Bighorn River in Montana was a bloody episode in what became known as the Great Sioux War.

So the mining started long ago, and hasn't stopped.

I drove on, heading for Colstrip through the blue dusk and into the night. Every now and again I descended one of the hills into a little velvet basin of pines and grass where the lone light of a ranch burned, but mostly there was only darkness until I reached the town, which was much more beautiful than I had imagined it would be. The power plant blinked, pulsed, and glowed like a brain hard at work, or a dream illuminated in the night. It sat right in the heart of Colstrip—beautiful yet ominous, like an electric toad, black as obsidian and laced with rows of light. It could have been the set for a Batman movie. A toxic citadel.

The four smokestacks of the plant are gargantuan by any scale other than that of the surrounding landscape, which dwarfs them, but there is no way that they could be sufficiently high to disperse all their poisons far afield, out into the hearts and minds of unsuspecting distant neighbors, and the effects were obvious. The atmosphere right next to the stacks was humid and deeply sulfurous. I remembered that people in Houston and Luling used to tell those who complained about the air that it smelled like money, and I realized with no small degree of disorientation that the humidity in Colstrip was from all the desert water pumped from underground, or from distant rivers, and used to attend to the cooling of the giant plant and the cleansing and ferrying away of toxins.

The town of Colstrip was created in 1923. It was a company town for the Northern Pacific Railway, which mined coal in the area. The coal was used to fuel the railroad's steam engines. In 1959, after the railroad switched to diesel-powered locomotives, the rights to the mine and the town were bought by the Montana Power Company. Colstrip was a typical eastern Montana quasi-ghost town of

a couple of hundred people in the early 1970s, but ten years later, during the construction of the coal-fired electrical power plant, the population had boomed to nearly 8,000. A little over 2,000 people live there now, most of them employed at the Rosebud Mine and by the current owners of the adjacent plant, a consortium led by Pennsylvania Power and Light. The coal from the mine is used by the power plant to heat water to make steam and then electricity, most of which is sent to consumers in the Pacific Northwest through hundreds of miles of power-transmission lines.

The term "sacrifice zone" is misleading. While it's true that southeastern Montana and the rest of the Powder River Basin are being razed, the term "sacrifice" implies cost in exchange for gain rather than loss upon loss. It's not just the devastation of the land that goes on the loss side. Burning Montana's coal increases our carbon footprint and accelerates global warming. And there are much cleaner sources of fuel than coal. Coal's just about as dirty as it gets, and in the West, Montana's is among the dirtiest. The extraction of Montana coal is above all else a story of faulty accounting—of costs that have been ignored. There are lawsuits flying everywhere—there have been for almost forty years—but the coal and power interests just keep marching through them. The politics of energy deregulation are complicated, and they have not been kind to this unpeopled landscape, where it can be challenging to accumulate a significant political constituency.

Water is one of the rarest resources around Colstrip. The water that's housed within the coal seams is often more valuable than the coal itself—particularly since Montana's coal is so dirty, with a low BTU content and high concentration of impurities such as sodium, thallium, mercury, boron, aluminum, and arsenic. Once these toxins are resurrected, one of two things happens to them in the relatively deregulated environment: they are burned and spread into the air, where they come down into the lungs and bodies of all who breathe, or they are trapped in filters. Small particles of waste material called fly ash are captured by scrubbers that exude a mist of water and lime and create a slurry that is piped into disposal ponds hidden back in the hills or into giant settling ponds, man-made shallow lakes of concentrated toxicity that are prone to rupture. So water sucked out of the Yellowstone River, thirty miles away, is being used to help power (via steam) and cool the generators and also

to treat the huge amounts of waste produced in the burning of coal. The previously high-quality Yellowstone River water itself becomes toxic, poisoning all it touches.

- •
- •
- •

One of the most well-known local voices against the coal interests is not what many would think of as a traditional environmentalist. He's a third-generation rancher who is also a cowboy-poet and performer. Wally McRae has served on the National Council for the Arts and has published several volumes of stories and poems. He and his son Clint run the Rocker Six Cattle Co., their family's thirty-thousand-acre spread, which lies south of Colstrip, between Rosebud Creek and the Tongue River. The McRaes have been ranching there ever since Wally's grandfather, John B. McCrae, emigrated from the Scottish Highlands in the late 1800s: hanging on in a harsh land.

I drove out to visit the McRaes one morning, arriving at their place while the crickets were still chirping, before the heat silenced them. Rosebud Creek wanders slowly past the ranch house, seeking the Yellowstone. A tire swing hung in the shade of an old tree. Dazzling light and clacking grasshoppers surrounded it. Several lilac bushes were drying in the sun, preparing for dormancy. Wally and Clint were in the kitchen, pouring coffee from a battered steel thermos, talking, plotting, strategizing.

Wally's weathered face seems to suggest somehow that he doesn't worry overmuch about niceties. He's been in too many tussles for too long at this point. He's fighting to preserve a way of life. Wally is not anti-coal—he burns it in his ranch-house stove—but he is pro-ranching. This distinction is one that got lost early on in the Colstrip battles, and talking to him and his family you can sense, in every clipped word, their despair. One of Wally's most popular poems, which catalogues the community's losses—the bulldozed homes and blasted land and ranches drowned in sludge—ends with the lines "nobody cares / About things of intrinsic worth." The McRaes' opponents are formidable. There are contracts to dig the coal, contracts to burn it, and contracts to put tons of the coal in railroad cars and send it to power plants hundreds of miles away. Sometimes after pumping and squeezing and baking all the water out of coal being transported, to reduce its shipping weight, new

water must be pumped back into the coal dust to make it less combustible, as if even in the moment we can't decide what we want. Too much, or not enough?

The largest fly-ash facility in the western United States lies outside Colstrip, about ten miles north of the McRae ranch. I tried to get into a settling pond and was sternly turned away, but I stood on the edge of town and watched dump trucks go back and forth, depositing a gray-black powdery residue—bottom ash—into mounds next to a glimmering playa and pond. The piles of ash were to be bulldozed into the pond, or paved and graded into the hollows and contours of the land and used as road fill for more dump trucks. The ash glittered like gray beach sand.

Almost all the constituents of coal ash are regulated or listed as hazardous, but the product, the final recipe with all those elements still in it, isn't deemed so, because that would put too much of a financial burden on the power companies. If it were listed as hazardous, they couldn't just drive it in open trucks out into the windy dump beyond town or pipe it, in a slurry of wild river water, to disposal ponds.

When the water from the poisonous man-made lakes leaks, it seeps back down into the underground formations and into the groundwater. Then it pops back up here and there, in bubbling fountains of toxic ooze, making little poisonous ponds in the desert that the power company fences off in order to protect livestock, though the birds and other wildlife cannot be kept out. The waste-water bulges up beneath the foundations of buildings in Colstrip, fracturing roads and sidewalks and warping the grocery-store flooring. It has contaminated the town's drinking water so badly that the power company had to agree to pump in other water, temporarily cleaner water, from the Yellowstone. Clint McRae says that there was "no reward in the win" of the lawsuit that put the town of Colstrip on city water. "How do you fix something like that? How do you fix a destroyed aquifer?" he asked. "There are just some things that are so destructive we shouldn't do them, no matter what they get us in the short term."

• • •

I stopped off at the Little Bighorn on my way home from Colstrip. The memorial was open this time, and I went in and looked at the markers, walking between the gravestones over the warriors and soldiers sleeping forever just below. Maybe, I thought, the coal—only a little farther down—could stay buried and sleeping too. Maybe it could sleep forever, like the soldiers who once, and not so long ago, in their arrogance and impatience, made a fatal mistake.

There is enough coal in Montana to end the world—to extinguish it in one long rogue flame. Still, we could get lucky. If the heaviest carbon-emitting fuels were taxed and if there were more encouragement to use lighter fuels that emit far less, if any, carbon, we might get out of this alive. I'm reminded of the old country aphorism about what to do when you find yourself in a deep hole of your own making. The first thing is, you stop digging and put the shovel down. It's advice I would give to the power companies and the mine owners.

I lingered longest at the marker for a warrior who died, the simple inscription says, "defending the Cheyenne way of life."

What will we give to change ours?

List of Plates

Frontispieces: Details of orthophoto maps, Rosebud Mine area, Colstrip, Montana, March 31, 1982 (1"=1,100'). 1. Mine area, industrial site, and residential areas. 2. Strip mine, industrial site, and unreclaimed mine land. 3. New mine area along Armell's Creek. 4. Company land between unreclaimed mine land and waste ponds.

Aerial photo mosaic, Rosebud Mine area, Colstrip, Montana, October 2, 1985 (1"=4,000').

1 Waste pond and evaporation ponds, June 23, 1984

2 New mine area along Sarpy Creek Road, June 23, 1984

3 New mine area, clinker, and mine roads along Armell's Creek, June 18, 1983

4 Excavation, deforestation, and construction of waste pond, June 18, 1983

5 Strip mine and railroad tipple along Armell's Creek, October 17, 1984

6 Strip mine, clinker, and new mine area, October 17, 1984

7 Unreclaimed mine land from the 1930s, October 17, 1984

8 Power switching yard, North Camper Village, and industrial site, July 18, 1983

9 Power plant, waste ponds, and residential areas, October 17, 1984

10 Power plant, waste ponds, and residential area, April 9, 1985

11 Power plant and waste ponds, June 18, 1983

12 Strip mine and abandoned farm, April 3, 1985

13 View from Montana State Highway 39: Sagebrush Court and power plant, March 31, 1983

14 Winchester Court: company houses built on reclaimed mine land, October 18, 1984

15 View from First Baptist Church of Colstrip: company houses and power plant, October 19, 1984

16 Burtco RV Court and power switching yard, June 5, 1985

17 View from State Highway 39: Cottonwood Drive and power plant, December 22, 1985

18 B & R Village Mobile Home Park and Burlington Northern coal train, June 21, 1984

19 Camper, Sweetgrass Neighborhood, April 1, 1985

20 Bachelor Village, Power Road, and power transmission corridor, April 2, 1985

21 North Camper Village and power transmission corridor, August 9, 1984

22 Camper, Sweetgrass Neighborhood, April 1, 1985

Acknowledgments

This book has been very much a collaborative effort and I have been fortunate to be assisted by some remarkable craftspeople. Katy Homans designed the book, Martin Senn made the digital scans and color separations, Thomas Palmer made scans of the mosaic and blueprints, and Daniel Frank supervised the printing of the book at Meridian Printing. Mark Holborn provided valuable assistance with the visual structure of the book and Sharon DeLano edited the texts. Richard Benson generously shared his printing insights and expertise with me. Ned Gray helped me make contemporary prints of some of the photographs. Rick Bass kindly agreed to write an essay. I am honored to have them contribute to this publication and I am truly grateful to each of them.

I am also indebted to many friends and colleagues for their generous assistance and support in the making of this book. I would especially like to acknowledge Lisa Dority, Vesna Glavina, Manjushree Thapa, Gordon McConnell, Hada, Rick Donhauser, Shepley Hansen, and Ken West. They have my deepest thanks for their many kindnesses.

Finally, this book is dedicated with love and gratitude to the memory of my parents, Constance and Norman Hanson. They continue to nourish me more than I can say.

—David T. Hanson

Design and typesetting by Katy Homans

Digital scans and color separations by Martin Senn

Printing by Meridian Printing, East Greenwich, Rhode Island, under the supervision of Daniel Frank

Binding by The Riverside Group

Published by Taverner Press

P.O. Box 2352, Fairfield, Iowa 52556

www.tavernerpress.com

Distributed by D.A.P. / Distributed Art Publishers, Inc.

155 Sixth Avenue, Second Floor, New York, NY 10013

Telephone 212-627-1999, facsimile 212-627-9484

www.artbook.com

Library of Congress Control Number 2010925843

ISBN 978-1-935202-20-2

A special edition of Colstrip, Montana is limited to sixty signed and numbered copies in a slipcase and accompanied by an original print by David T. Hanson. For information, contact Taverner Press.